Art and Worship:
A Vital Connection

Art and Worship:
A Vital Connection

by

Janet R. Walton

A Michael Glazier Book
THE LITURGICAL PRESS
Collegeville, Minnesota

A Michael Glazier Book published by The Liturgical Press.

Typography by Phyllis Boyd LeVane.

3 4 5 6 7 8 9

Library of Congress Cataloging-in-Publication Data

Walton, Janet Roland.
 Art and worship : a vital connection / by Janet R. Walton.
 p. cm.
 Reprint. Originally published: Wilmington, Del. : M. Glazier,
1988.
 "A Michael Glazier book."
 Includes bibliographical references and indexes.
 ISBN 0-8146-5736-2
 1. Christianity and the arts. 2. Liturgics. I. Title.
[BR115.A8W35 1991]
246—dc20 91-3379
 CIP

TABLE OF CONTENTS

For my parents
Helen Walton-Curtin and Jerome Richard Walton

teachers of wisdom
models of courage
lovers of life

Foreword

by Robert McAfee Brown

"He didn't know where he come from" one of the characters in Alex Haley's *Roots* says of her son, "so he didn't know where he was goin'."

It's an appropriate rejoinder to the reader who picks up Professor Walton's book (perhaps hoping for five handy ways to improve Sunday morning worship) and asks, "Why are we starting out in the middle of the Euphrates Valley somewhere around 200 C.E.? What has *that* got to do with making a vital connection between Art and Worship?"

And the answer has got to be, "Only everything." For in examining what went on in that tiny church in Dura-Europos, and in the massively different church of Saint-Denis many centuries later in Paris, the author positions us to look at the present by making clear that if we don't know where we came from, liturgically and artistically and in every other way, we won't know where we are goin'.

Important lessons are learned from these two historical examples that arm us with insights for examining, as the rest of the book does, the ways in which those in the arts and those in the church can assist one another.

It is not the task of theologians to underscore how much they need us; it *is* the task of theologians to underscore how much we need them if we are truly to understand our faith, let alone communicate it to a world that by and large couldn't care less about the Christian message. And it is one of the author's achievements, perhaps her greatest, that she shows how bridges can be built between the two communities.

"Connections" is a very big word for her, and for understanding her text.

One reason Janet Walton can do this so well is because she lives in both communities. She is a musician with professional graduate training in piano, and she is also a seminary professor with professional graduate training in theology and liturgy. Most of us settle for one competence, so we need help in bridge-building from the two-competence people, and the present text is the fruit of the labor of such a one. And while I can't grade her on how well she plays the "Waldstein" Sonata, I can report that her theological discussion of "transcendence," for example, is a stunner.

I will highlight one reason why Christians need artists of all sorts in rehabilitating our liturgical life—a reason that may be implied but is never quite so baldly stated in Professor Walton's pages: we need their help so that we can get beyond the almost unrelieved boredom of so much of our corporate worship. This is not, I hasten to add, to say that sculptors or dancers or poets are to be sought simply to spice up our bland Sunday mornings with a little novelty. It *is* to say, most emphatically, that the message that has been entrusted to us, and which we have so deeply betrayed, is at such a far remove from dullness, that it is almost an oblique tribute that we have been able to transform it so spectacularly into something unspectacular. For the Christian message, before we laid hands on it, is a story with craggy surprises, unexpected turns, unlikely heroes, even more unlikely heroines, not to mention a God who not only hovers over all but frequently makes either blatantly vigorous or extremely subtle entrances into the story—and we never know ahead of time which it will be, or whether we will even notice. So we either miss the divine presence, or clothe it with such familiar verbal and physical trappings that no one could care less.

And it is the particular contribution of artists (one among many), that they have an uncanny ability to find the extraordinary in the midst of what to the rest of us is the ordinary. "Can any good thing come out of Nazareth?" the sceptics queried when Jesus appeared in the scene, and if there had been an artist on that occasion, he or she would have said, "You bet!" or at least, "Why not?" Not only that, but she or

he would have gone on to depict for us, in song or on canvas, the uproarious and splendid notion of the boondocks being the place of the supreme divine activity, and doing so with enough passion that we couldn't miss the point.

On another level, artists use the drab materials at the disposal of everyone else, and create unexpected beauty for everyone; by crossing horsehair over catgut they give us the "Kreutzer" Sonata, and we say "Of course!," though without the artists the idea would never have occurred to us. Or they take a symbol that appears worn out in our contemporary culture—the cross, to offer a not exactly random example—and re-present it in the exciting, and often highly controversial, forms that Professor Walton describes in Chapter IV.

The artists, it seems, not only have an infinite capacity for excitement, but also a high degree of capacity to excite us, by celebrating the excitement in what has become ordinary to the rest of us. And what better arena in which to exercise those dazzling gifts than the arena in which sights and sounds and water and wine and stumbling words and gestures and textures and light and space and color are all trying to communicate something that cannot ever be adequately communicated; better yet, to communicate Someone who cannot ever be adequately communicated?

Instead of accepting that set of conditions as a defeat, the artists see it as a challenge. Let's try again. Maybe we can get closer this time. How about this new analogy or that metaphor? What if we tried a stone instead of a canvas, or wrote a chorus to celebrate what the preacher can only mumble?

The following pages convey something of this excitement— the possibility of new things breaking through old forms and even on occasion, emerging from them, and empowering us to begin again. I would offer a summary of the argument if that would persuade. But no summary is needed, for the text is there.

Turn the page and see.

Introduction

Several years ago there was a memorial Mass for the renowned French musician Nadia Boulanger. Her influence among American composers is legendary. She is known not only as an eminent teacher of composition but also as a friend to many of America's most significant composers. The service brought together many of these friends as well as others who respected her life. In a well-filled church the Roman Catholic Mass proceeded as usual, emphasizing the finitude of this life and the eternal happiness of life with God.

Not until near the completion of the liturgy was any concrete connection made with the life and work of Nadia Boulanger, whom the churchgoers had come both to mourn and to honor. Fortunately, just before the final blessing, Aaron Copland moved to the front of the nave. He spoke a few words about his experience as her student. Perhaps her most unrecognized talent, suggested Copland, was her ability to see the potential of aspiring musicians before they could see it for themselves. She recognized that potential, nurtured it, and disciplined it. Many composers are successful today because of her insight and training.

Copland's comment connected the preceding liturgy with Boulanger's life for every person there. Here was a woman, he reminded us, who lived her life fully, encouraging others to do the same. Here was a woman, he continued, who modeled risk, courage and steadfastness at a time when women worldwide were experiencing discrimination and relentless challenges to their authority and reliability. But, without the words

of Aaron Copland, there would have been no clear connection made between those triumphs that the liturgy celebrates and the qualities of Boulanger's life.

Another instance provoked questions about the apparent ease with which liturgy can become divorced from life. It was born out of standing in a long line of people waiting to get tickets for the Picasso retrospective in New York City. One could not help wondering why there was so much interest in the work of Pablo Picasso. Undoubtedly some of it was sparked by the intensity of media coverage. But there was a deeper reason, as Grace Glueck noted, "He was the foremost painter of reality; he proposes the question 'What is reality' and put his own life into his work."[1] Picasso's paintings offer insights about humankind and its relationship to history that many people yearn to understand.

While standing in the line as it slowly inched forward, I wondered: *Why are museums, concert halls and theaters more crowded than churches?* Do aesthetic experiences provide more focus than church services? Do encounters with art change more profoundly the way people understand and live their lives than encounters with "religion"? Apparently artists have something to share with liturgists.

The key to the problem, I believe, is that artists understand how to make connections. Artists like Picasso express what is intangible in ways that people can grasp. And as the effectiveness of rituals in churches, temples, shrines, and homes decreases, it seems clear that what is lacking is connection. New hymnals, renovated church spaces, more communal participation by way of praying or reading together, better trained leaders, all these are not enough. What we need are connections: expressions of the need to love and be loved, or the fear and reluctance to die, that are connected to the faith of our particular religious tradition. We need assertions of tangible concern about the inequity so pervasive in our world, and within the demands of ritual we need an indication of a will to challenge systems that perpetuate injustice. We need to know what it is to believe in a God who is intimately involved

[1]Grace Glueck, "A Show That Might Even Have Dazzled Picasso," *New York Times*, June 22, 1980.

with human realities, a God whose "essence" may be difficult to understand, but who nevertheless is present in familiar and unfamiliar forms. We need to link joy with God and one another.

What are the ingredients of ritual expressions that do provide such connections? They are not often in printed prayers distributed for universal use. They are not often in biblical texts hastily read as if to be merely gotten through in order to hear the sermon. They are not often in hymns, which have become routine in their performance and outmoded in their texts. Inevitably, they are created expressions, chosen, performed, organized or conceived by a member of the community. They are words or movements or sounds expressing mystery mixed with reality that emerge from other persons' experiences.

As a seminary teacher of courses in worship, and even more as a person who wants and needs liturgical experiences that invite my own as well as a community's transformation, I have considered options for providing such possibilities not only within familiar liturgical forms but also in new ones. I have turned again and again to artists and to art as a source for materials, ideas, and structures—both contemporary artists and earlier artists who have created what we have inherited. Art can express our deepest yearnings and feelings in forms with which we can identify.

This book, then, deals with ways in which the arts can be used within worship to provide connections between what is invisible, that is, human faith and divine reality, and the palpably deep longings and concerns of our being.

Since controversies and questions about art and worship in the present always have some historical precedents, Chapter One sets an historical context for this discussion. It focuses on contrasting liturgical communities in two influential eras of liturgical history, the church of Dura-Europos in the third century, and the church of Saint-Denis in the twelfth. Such information is interesting not only in its own right, but can also suggest things we will want to include or to avoid in our worship today.

Chapters Two and Three describe an "evolving tradition," in the one case ecclesial, and in the other, artistic. In Chapter

Two, the emphasis will be on the church, with a discussion of qualities needed in the contemporary church and liturgical implications that flow from them. In Chapter Three, the focus will be on artists. How do artists work? What does their art communicate?

The fourth chapter points to the future. It will give specific examples of ways in which artist and church can work as partners, suggesting how artistic creation can contribute to the authenticity and effectiveness of worship. Anything more than a superficial, temporary response requires the kind of meaningful partnership suggested here. While such collaboration is not new, it needs constant evaluation just as liturgy does. This chapter provides examples of such collaboration while underscoring the need to identify the distinctive contribution art can make to liturgy.

The final chapter offers principles for a working partnership. Different approaches in this working relationship can make collaboration difficult. Therefore it seems wise to anticipate problems and possibilities and thus ease the process of learning to work together.

My lifetime experience as a Roman Catholic and ten years of work and study in an interdenominationally Protestant seminary have influenced the preparation of this book.

From the Catholic tradition I understand well the potential of nonverbal symbols: the fullness inherent in their ambiguity, the truths expressed by their presence. For example, the regular use of water, light, bread offer possibilities for understanding the mysteries of transcendent and human realities that no words can express. The repetitiveness of the Catholic rites has opened my eyes to the value of ritual components and the need for predictable, familiar elements in liturgies. However, that a Roman Catholic liturgy can proceed without any or with only minimal awareness of the concerns of a particular congregation is disastrous. It is not enough simply to use the language of the people and to acknowledge their culture. It is imperative to connect the meaning of liturgy with the everyday realities and mysteries of a community. Because Roman Catholic rites are so carefully prescribed, this connection often is neglected.

From the Protestant tradition I appreciate profoundly the

respect for disciplined sermon preparation. Acknowledgment of the intricacies of the biblical text inspires attentive listening. I have also learned about the effectiveness of good hymn singing, its power to create a dynamic momentum and to reveal qualities of divine and human realities. However, often too many words overwhelm the service. They make concentrated interaction impossible. The service has no readily identifiable focus; it seems to be a series of events rather than a carefully planned ritual.

Although much more limited, experience in other world religions also informs the perspective presented in this book: the vitality of memory inherent in Jewish celebrations, the reverence for beauty in Shinto festivals, rhythms of sound and silence in Buddhist and Hindu rituals, respect for the text in Moslem gatherings, and the integration of mysticism and human connection in Shaman performances.

A deep appreciation of the need for liturgy motivates my study of many rituals. A belief in their value and the ways in which an understanding of art is essential to their enactment provided the interest and incentive to write this book.

The completion of this work was a collaborative effort. Family members, Kathy, Brad, Nancy, Bob, Brendan, Rob, Mary Beth, Mark, Pat, Brian, Rick, Marieé, Dan and H.S. offered loving support. Students, staff, and colleagues at Union made significant suggestions and provided companionship along the way not only for this writing, but in the critical and imaginative work of planning worship in James Chapel. I am particularly grateful to Jake Empereur who invited me to write this book, to Staley Hitchcock for his typing, to Seth Kasten for his ever watchful eye to locate appropriate research materials, to Ardith Hayes and Eleanor Meyers for our regular gatherings to critique our work in progress and to Robert E. Seaver, not only for many comments on the manuscript, but also for the privilege of working and learning with him. His commitment to discovery and his willingness to do the hard work involved in creating a partnership between artist and church abetted and strengthened my own. Friends provided crucial encouragement: Members of my community, The Sisters of the Holy Names of Jesus and Mary, contributed persistent affirmation; Mary C. Ragan, Annette T. Covatta,

Anne E. Patrick, and Lawrence A. Hoffman offered critical comments and support; Richard S. Vosko read the entire manuscript, making many practical suggestions from his work as a liturgical design consultant; Robert McAfee Brown proposed invaluable changes on numerous drafts; and Ann Patrick Ware read every word tirelessly, many times providing suggestions on all aspects of it, from editing and organization to ideas as well as continual affirmation of this project. I am grateful to all of these persons not only for their particular help with this book but primarily for their friendship and interest that have sustained and inspired my work.

New York, New York Janet Walton

1

An Inherited Tradition: Art in the Worshiping Communities of Dura-Europos and Saint-Denis

The Christian communities at Dura-Europos in Syria and at Saint-Denis in Paris offer vividly contrasting examples of ways in which the arts contribute to the activity of worship.

The comparisons are not as simple as they may seem at first. There are many factors—social, economic, aesthetic, theological, historical—that play a role in developing liturgical experience. This chapter will describe the needs of these two worshiping communities and the resources they called upon and will provide data for considering how two churches in vastly different periods understood the arts as components of worship. Let us examine them in turn.

Dura-Europos

In the midst of routine procedures to establish order in the Near East after World War I, an officer of the British army, stationed in the Syrian desert along the middle Euphrates River near the village of Salihiyah, reported a remarkable discovery. He had found wall paintings on some ancient ruins that opened a door for extensive research on artistic, religious and cultural history between 300 B.C.E. and 256 C.E. Excavations started on the site, called Dura, in 1922 and continued for fifteen years. The work marked the beginning of

"impressive and valuable discoveries, far beyond anyone's dreams."[1]

The community of Dura-Europos was established c.300 B.C.E. by Nicanor, a general in the contingent of Seleucus I, as part of the Greek expansion to Asia Minor. Dura, as its name implies, (*dur* means hard) served as a fortress for the Greeks. Its location overlooking the Euphrates River was ideal, providing both shelter for merchant caravans and more importantly positions from which it could defend itself. In Dura's early history the nomad tribes were a constant threat to its control.

The life of the Greeks in Dura was relatively quiet until 185 B.C.E. when the Parthians began a series of attacks against them. From that time Dura was under constant siege, first by the Parthians, then the Romans beginning around 115 C.E. and finally by the Persian Sasanians who destroyed Dura in the middle of the third century.[2]

This succession of influences in Dura contributed significantly to its eclectic history, each culture adding its own distinctive features. The archaeological evidence uncovered in Dura suggests that different perspectives and traditions existed side by side and inevitably over the course of time became intertwined. This cross-fertilization can be seen clearly in the religious practices of Dura as illustrated in painting and sculpture. Two examples are the star-studded dark blue sky in both the Christian baptistery and the Mithraeum (a cave-like building associated with the worship of the Persian god, Mithra) and the sculpture of the Roman god, Zeus, in Parthian dress in the temple devoted to him. Though the local tradition was dominated by the Greek language and culture, the Parthian Mithra, Roman gods, Christian and Jewish beliefs as well as Greek cults and temples overlapped in the shaping of the Durene religious culture. Ideas and practices from both the East and the West contributed to this mixture. Ann Perkins comments: "The picture then is one of a basically

[1]Clark Hopkins, *The Discovery of Dura-Europos*, ed. by Bernard Goldman (New Haven and London: Yale University Press, 1979), p. 6.

[2]For details of the history of Dura-Europos, see *The Discovery of Dura-Europos* by Clark Hopkins, cited above, pp. 251-264.

Semitic religion with various accretions from the Western world, mingled to form a purely local idiom."[3]

The art of Dura reflects similar syncretism. The local tradition formed a base upon which other perspectives were added and combined. In fact some scholars suggest that this layered style is the primary contribution of Durene art. "The interest and the significance of the art of Dura lies not in technical skill or aesthetic achievement, but in the mingling of different influences and the adaptation of foreign ideas to form a characteristic local style."[4]

THE CHURCH OF DURA-EUROPOS

To this diverse culture, Christianity was introduced in Dura during the Roman occupation about 163 C.E. The composite Gospel of Tatian, the Diatessaron, composed in Syria around 172 C.E. and written in Greek, was used for the transmission of the Christian narrative and ideals.[5] The primary source of information about the life of the Christian community in Dura during its short life has been gleaned from the available evidence in a house church which was excavated between 1930-1934.[6] The house, built originally in 232 C.E., was adapted specifically in 240 for the needs of the church.[7] By 256 the community was dissolved when the city was destroyed. However, because of the foresight of the Durenes, who filled in the structures in Dura with earth, brick and debris and built an embankment against the walls already surrounding the city,[8] there is an unparalleled source of early religious and

[3]Ann Perkins, *The Art of Dura-Europos* (Oxford: The Clarendon Press, 1973), p. 9.

[4]Ibid., p. 9.

[5]Hopkins, p. 260.

[6]Carl H. Kraeling, *The Christian Building*, with a contribution by C. Bradford Welles (New Haven: Dura-Europos Publications), distributed by J.J. Augustin Publisher, Locust Valley, NY, 1967 in a series entitled *The Excavations at Dura-Europos, Final Report VIII, Part II, The Christian Building*, C. Bradford Welles, editor.

[7]Ibid., p. 38.

[8]Hopkins, 1979, pp. 245-249.

cultural history in Dura-Europos available for our exami-
nation.[9] Admittedly, this particular example of liturgical
history is limited by its distinctive local characteristics and the
lack of many other bases for comparison. However, with this
qualification, it is possible to speculate about what archae-
ology has unearthed and draw some conclusions from the
evidence that is available.

At this time in liturgical history, worship was an intentional,
corporate activity. It was not a time for private prayer. The
responsibility for worship was shared by each member of the
community: bishop, presbyters, deacons, laity, catechumens.
Corporate action of distinct groups within the worshiping
body was the most important aspect of their worship, more
significant than what they said. This form of collaboration
was a witness to participants of the unity of the church,
Christ's life among them, and their eschatological hope. The
liturgies were not public displays of distinctive religiosity or
power. On the contrary, they were exclusive meetings for
Christians only. Converts were admitted in stages. Most likely,
the form of worship was in two parts, sometimes separated
by a period of time: the synaxis (readings from the prophets
and the memoirs of the apostles, the singing of psalms, a
sermon and set prayers) and the eucharist (a liturgical meal
expressing thanksgiving for the activity of God on behalf of
humankind throughout human history, particularly remem-
bering the redemptive work of Jesus and calling forth the
presence of the Spirit into our midst). From historical ac-
counts aided by some speculation, it is presumed that these
celebrations were enthusiastic, singleminded and wholehearted
expressions of thanksgiving and praise.

The house church at Dura had eight rooms: a courtyard,
portico, vestibule, assembly hall, baptistery, and three addi-
tional undesignated rooms. The baptistery and assembly hall
provide the most concrete information on early Christian
liturgies. Because the baptistery was adorned with wall
paintings, it offers invaluable data on the use of art as an

[9]During this same period there was an active Jewish community whose synagogue
offers significant information about art and worship. However, the exploration here
will be limited to the Christian community.

integral part of worship.

The baptistery is identified by the presence of a basin set into the floor, a masonry canopy over the font, and the presence of wall paintings.[10] Baptism was understood by the early Christian community as a pivotal process in a person's life. Records that describe the preparation period and the rituals enacted indicate the seriousness with which the action was regarded. At that time it was the practice of many local religious traditions to decorate the most important room in the house in a specific style.[11] Therefore it is no surprise that the baptistery was chosen for paintings.

The art in the baptistery consists of eight scenes, two from the Old Testament, six from the New. The major painting, located behind the basin, its placement indicating its importance, is the Good Shepherd and the Sheep. Below it, and certainly in relation to it, is the Fall of Adam and Eve. On other walls are the Procession of the Women to the Sepulcher on Easter Morning, the Healing of the Paralytic, Jesus Walking on the Water, The Woman at the Well, David and Goliath, and a garden scene.[12]

For the community at Dura, these subjects described significant moments in the history of God's relationship with people, emphasizing a divine response to human beings in need. Jesus as a symbol of God is understood as a protector, a prophet, a compassionate friend, a healer, a miracle worker. The paintings communicated to their viewers eschatological qualities as well, primarily hope in a future that was different from the limitations of the present time because it was enabled by the power of Christ.[13]

[10]A full discussion of the baptismal font and the canopy may be found in *The Christian Church* by Carl H. Kraeling, pp. 148-150. With regard to the canopy, Kraeling notes that related buildings in Dura show similar structures delineating a particularly important part of a room.

[11]Ibid., p. 41.

[12]For a detailed interpretation of these paintings including some speculation on a rationale for their placement see Kraeling, pp. 206-213, Perkins, pp. 52-55, and M.I. Rostovtzeff, *Dura-Europos and Its Art* (Oxford: The Clarendon Press, 1938), pp. 130-134.

[13]Joseph Jungmann, *Pastoral Liturgy* (London: Challonor Publications, 1962), p. 4.

The assembly hall also had particular significance for the liturgical life of the community. It is a large room (originally two smaller ones) which spanned the length of the house church. It is assumed that this room was renovated to provide a space for the celebration of the eucharist, and could accommodate as many as 60-70 persons. A low raised platform set against the eastern wall, probably used by the person presiding, also suggests this use.[14]

There are no wall paintings in the assembly hall. The reasons for this situation can only be conjectured. Clearly, the existence of the building as a church was very short, only sixteen years. Perhaps there were plans to decorate this room as well as the baptistery, but there was not enough time.[15] Some suggest that the baptistery had a character and an importance not shared by the assembly hall and therefore the choice to confine wall paintings to the baptistery was intentional. (This argument seems weak given an understanding of the distinct importance of the eucharist for the ongoing life of a Christian community.) Others think that the baptistery itself could have served also as a room for the eucharist especially when it was the conclusion of the rite of baptism or when the number of those who gathered for eucharist was small.[16] This possibility implies that the assembly hall could have been used less frequently than the baptistery, and therefore, there was no need to decorate two rooms. While it is difficult to conclude definitively from the minimal evidence available, either the short existence of a Christian community at Dura, or the less frequent use of the assembly hall, seem to be more sustainable arguments for the choice to limit wall paintings to the baptistery.

ART IN THE CHRISTIAN COMMUNITY AT DURA

The importance of art to this early Christian community is connected to its understanding of liturgy as an intentional,

[14]Kraeling, p. 143.

[15]Walter Lowrie, *Art in the Early Church* (New York: Pantheon Books, Inc., 1947), p. 35.

[16]Hopkins, p. 116 and Kraeling, p. 151.

corporate activity rather than as a private, individual exercise. Though we can only imagine how art functioned to support their liturgical experience, such speculation is helpful for our consideration of the role of art in the contemporary church. There are at least four areas in which art contributed to the Dura worshiping community, for which there is some supportive data:

1. Art stimulated memory

The ability to recall specific expressions of divine/human relationships in the history of humankind enhanced the community's capacity for a response to contemporary situations.[17] The subjects chosen for the paintings in Dura illustrate the community's need to relate timeless human concerns to divine providence and power. The art depicted narratives that expressed healing when faced with sickness, compassion in response to fear, freedom from oppression, conversion from destructive choices, and power over death. The art portrayed divine power as dynamic, persistent, and not limited by human imagination. For example, Jesus' companions probably could not have predicted his conversation with the Woman at the Well nor the choice of women rather than the twelve to witness his resurrection. Yet these stories were part of the biblical narrative and vividly conveyed the spirit of the divine/human relationship. The memory of these situations offered hope to the Christians at Dura. For the Durenes, art helped to stimulate this recall with concrete images of the activity of God in the midst of the needs of humankind. It provided the potential for multi-sensual understanding of the spirit of Christianity.

Not only did the art recall divine/human sensitivity in vital concerns, it also stimulated reflection on paradigms for human interaction. These paradigms uncover characteristics of divine life among human beings. They establish ideals against which the community is invited to examine itself. The painting of the Good Shepherd suggests love that extends beyond obligation; the depiction of the Woman at the Well describes

[17]Lowrie, p. 27.

active involvement that disregards acceptable societal restrictions; the story of Adam and Eve describes the implications of the choice of death over life.[18] The interpretations do not end with the explanations passed on to this community, nor are they limited to a first response. They change as our experiences for interpreting them develop. Our memories are continually refurbished with new insights into the paradigms of divine/human relationships in these paintings.

2. *Art depicted the demands of the Christian gospel.*

To claim membership in the early church was not a symbol of societal privilege. Consequently, it was not enough to attend the liturgy on Sunday. Membership in the Christian community demanded active engagement in the total life of the community. The paintings illustrate some experiences Christians could anticipate. The picture of the women coming to the empty tomb suggests the prevalence of resistance and perhaps suspicion that Christians may expect among themselves as well as others. Since Jesus had been crucified for challenging traditional customs and the ultimate power of political authorities, caution and fear marked the movements of the early Christians. The women came to the tomb to provide proper care for the body of Jesus. Finding what they could not have predicted and yet anticipating the competition and jealousy that was inevitable in their community, they announced what they had seen, but most likely were not surprised by the response of disbelief. The women as well as all Christians would face challenges to their faith regularly. The story of the Good Shepherd, with varied interpretations, also conveyed the unpopular choices in which they could be involved. To leave the majority to attend to the minority requires courage and determination. The depiction of the Woman at the Well predicted the difficult societal pressures conversion entailed. Jesus crossed racial and class barrriers in his conversation with this woman in Samaria. The power of these distinctions can unearth violent reactions and resistance. The story simply acknowledges the possibilities.

[18]See Phyllis Trible, *God and the Rhetoric of Sexuality* (Philadelphia: The Fortress Press, 1978), pp. 72-143.

The art of Dura carefully invited the community to ponder and prepare itself for a life of constant challenge.

3. *Art complemented oral instruction.*

Ongoing instruction in the Christian faith was the heart of the experience of new Christian communities. The understanding of that faith was a process, begun in the preparation for baptism and continuing throughout a person's life. Art provided visual images that complemented and expanded verbal explanations. Images of ordinary folk made vivid, immediate connections with the lives of the people. Unlike art in the fifth and sixth centuries, where one of the primary intentions was to reinforce a particular tenet of faith or an aspect of institutional authority, the art in Dura was intended more modestly to bridge the gap between the concrete needs of the people and the response of the Christian Gospel.[19]

Art met these needs in a distinctive way by providing an experience of the emotional content in the narratives selected. The stories evoked a gamut of feelings: grief, loss, compassion, love, personal concern, fear, surprise, anger, anxiety, exasperation, to name a few. To look at the paintings of Jesus walking on the water or his healing of the paralytic evoked confidence while the portrayal of Adam and Eve elicited reflection on ther implications of a choice of death over life. Such feelings are regular companions in the journey of all human beings.

Art invites worshipers to discover their total being in the Christian story and to find insights as well as motivation in their involvement.

4. *Art stimulated a variety of senses.*

Participation in art involves more than seeing. It also requires listening, sometimes smelling, or touching or tasting. For example, to grasp the meaning of the living water as an image of divine presence, it is critical to know its feel, its thirst-quenching power, its refreshment, its sounds, its destructive potential, and what it is like to be without it. In that

[19]It is important to note, however, that the juxtaposition of the paintings of the Fall of Humankind near the Good Shepherd certainly indicates the role of Christ in the process of redemption. Perkins, p. 53 and Kraeling, p. 200.

sensual engagement the fullness of the gift of living water can be grasped. To understand the healing of the paralytic, it is helpful to call to mind impairment of any kind, what it feels like not to be able to walk, talk, eat, without pain or without help. The paintings describe change. Within each narrative there is movement. To appreciate its meaning, it is important to reach with all the senses in and around the painting to feel the engagement.

It is the distinctive capacity of all forms of art to express what is often intangible through discursive language. Even more within the power of art is the ability to touch multiple aspects of human experience at the same time. As Susanne Langer points out: "What [art] does to us is to formulate our conceptions of feeling and our conceptions of visual, factual, and audible reality together. It gives us forms of imagination and forms of feeling, inseparably; ... it clarifies and organizes intuition itself."[20] The paintings in the baptistery in Dura offered this type of engagement to the Christian community through simple, unsophisticated expressions.

THE DURENE COMMUNITY AND THE CONTEMPORARY CHURCH

There are two additional features of the use of art in Dura that are pertinent to contemporary liturgical experience. First, the art expressed the dynamic qualities of the demands of faith as they were known in this specific community. The rhythms of life in Dura were fast and irregular. In a town that catered to trade, new ideas and possibilities were more the norm than the exception. The Durenes were challenged to differentiate what was important and discover ways to hold on to their conclusions. The choice of painted narrative scenes, depicting the unpredictable experiences and demands of this new religion, reflected these early Christians' perception of their faith. They saw in this art an active expression of divine/human interaction applicable to their most critical and

[20]Susanne Langer, *Feeling and Form* (New York: Charles Scribner's Sons, 1953), p. 397.

yet their most common concerns, providing images of courage, strength and protection that spoke concretely to the present joys and sorrows of that community. For example, the particular emphasis in the picture of the Good Shepherd at Dura is not its eschatological interpretation but the intimate concern of God as symbolized in the shepherd about the real anxieties of the people, i.e. danger to the sheep, food, and protection.[21]

That members of this community chose art to aid them in their quest not only reflects the religious practice of the time but also their recognition of its value for them. These wall paintings were stories about human beings just like the Durenes. They reflected both the drudgery and the vitality of life. "The omnipresent frontality, static postures, and expressionless faces make this a stern art, impressive rather than beautiful, strong rather than graceful, abstract rather than realistic. It is a good reflection of a frontier garrison city which served three empires."[22]

The connection between the Christian story and the contemporary needs of the Christian people is not a new challenge in the church. However, the relationship between the ways the story is communicated and the connection with the everydayness of life needs constant re-evaluation. The choice of accessible art particularly applicable to the ongoing life of a specific community is an effective way to present the living application of the ideals of the Christian faith. The Durenes demonstrated a way to maintain an accessible connection through the use of art that can serve as a model for us today.

Second, critics suggest that the presence of wall paintings pointed to one of the early Christians' expectations of worship: a "personal and collective encounter with God."[23] Services that offered comfort or inspired personal piety would not have been appropriate for the members of these communities who were concerned about physical survival and the development of this young religion. They presumed that their worship would include experiences of confrontation, of wonder, as

[21]Kraeling, p. 214.
[22]Perkins, p. 126.
[23]Lowrie, p. 113.

well as sustenance. The choice of the specific narratives for the wall paintings affirms this perspective in their emphasis on intervention and invitation rather than simple adherence to a set of beliefs.

The variety in the styles of art in the Dura house church, perhaps a situation imposed by need as well as choice, by their diversity broaden the potential for interaction and encounter. Any gathering of people inevitably implies some diversity of experience. Such diversity presumes a variety of needs. To meet these needs, more than one interpretation of divine/human relationships is welcome. Art provided this internal variety.

Discussions about the art at Dura-Europos have raised questions about its aesthetic value. In comparison to the artistic quality of the paintings in the nearby Jewish synagogue, it seems poor. But, before judging it too harshly it is important to consider the primary purpose of the art in the Dura baptistery. Most scholars agree that for the worshipers the emphasis was the content rather than the visual effect of the art.[24] The principal intent was not to meet aesthetic standards, but rather, as Margaret Miles says, commenting on the use of religious images in a worshiping context, "to move, to focus the senses and the mind, and to offer a mnemonic aid that gathers the worshiper's strongest and most fundamental ideas, emotions, and memories in an enriched present."[25]

Indigenous artists or artists who have spent a considerable amount of time with a community know the most immediate concerns and passions of the people with whom they live. The expression of them as part of the community's worship testifies to the capacity of the Christian Gospel to respond appropriately to varying concerns of a particular group of people.

[24]Perkins, p. 55.

[25]Margaret R. Miles, *Image as Insight: Visual Understanding in Western Christianity and Secular Culture* (Boston: Beacon Press, 1985), p. 9.

Saint-Denis

Like Dura-Europos, Saint-Denis, an industrial city in the northern suburb of Paris, is known to art historians and students of liturgy for its construction of a church. Unlike Dura-Europos, the church of Saint-Denis was not threatened early in its life. A structure stands today, significantly changed from its earlier styles, but with vestiges of its history. These remnants, as well as the work of excavators and written resources, provide data from which to think about the inter-action of worship and the arts during the Middle Ages. Though the entire history of Saint-Denis is a valuable source of information on this topic, this examination is limited to the period 1122-1151, during the leadership of Abbot Suger. Through his writing about the major reconstruction of the church he offers clear aesthetic and liturgical priorities for our consideration.

THE CHURCH OF SAINT-DENIS

The first structure on this site was erected c. 475 C.E. by St. Genevieve to honor Denis, and Eleutherius and Rusticus his companions. Denis, the first evangelist and bishop of Paris, was a contemporary of the apostle Paul. After Paul's death, Denis left Rome to begin the conversion of the people in Gaul. After some initial success, Denis, Eleutherius and Rusticus were executed by Roman civil authorities and buried on the site where Saint-Denis is now located. Many legends describe Denis' activities, especially his extraordinary walk to his burial site after being decapitated. It is difficult to establish proof for any of these facts. However, the building of Saint-Denis was significantly affected by both fact and legend.[26]

Suger assumed responsibility for Saint-Denis when he was elected abbot in 1122. In addition to significant leadership in the abbey which led to his election there, Suger was a distin-

[26]For information on the legend of St. Denis see *The Abbey of Saint-Denis, 475-1122*, Vol. I by Sumner McKnight Crosby (New Haven: Yale University Press, 1942), pp. 24-40.

guished political leader as minister to Louis VI and Louis VII and Regent during the Second Crusade. His influence in both ecclesiastical and political circles provided access to power and resources that contributed to the fulfillment of his dream of a reconstructed church.

Suger inherited a Carolingian basilica that had been built in the eighth century. It had a cruciform shape similar to other Latin basilicas, with a nave and side-aisles, a single apse and a small transept. Reputed to have been an exceptionally beautiful building, it paved the way for the future developments of Romanesque and Gothic architecture.

From its beginning, the interest of the monarchy and its financial resources made possible a lavishness which marks the history of Saint-Denis.[27] The building served two purposes: it provided space for the liturgical activity of the monks who lived in Saint-Denis, and it was a burial place for royalty, whose political influence along with material support was critical in the development of the church building.

Suger's dreams of a reconstructed church coincided with the desires of the monarchy for a more appropriate monument. Suger wanted a church that would testify more fully to the magnificent splendor of God through its structure and liturgy. The monarchy for its part, also desired a glorious structure, one that would acknowledge its eminence, record its contributions to history, and be a place that would enhance the centralized political power of the Capetian monarchy.[28] As a result, church and political powers cooperated in the building of an edifice that satisfied both dreams. At the same time, it signaled a change in the evolution of church buildings and spoke eloquently about art in a liturgical context.

Suger began the reconstruction and redecoration of the

[27]For a detailed history of the building of Saint-Denis see *The Abbey of Saint-Denis* by Sumner McKnight Crosby. See also *The Chronicle Tradition of Saint-Denis: A Survey* by Gabrielle M. Spiegel (Brookline, Mass. and Leyden: Classical Folia Editions, 1978); *Suger* by Marcel Aubert (Editions de Fontenelle: 1950); Thomas E. Polk II, *The Early Gothic Chevets of Saint-Denis and Noyon: Methodological Considerations* (Ph.D. dissertation, 1976, The Pennsylvania State University), Xerox University Microfilms, Ann Arbor, Michigan.

[28]Sumner McKnight Crosby, Jane Hayward, Charles T. Little, William D. Wixom, *Royal Abbey of Saint-Denis In the Time of Abbot Suger (1121-1151)* (New York: The Metropolitan Museum of Art, 1981), p. 103.

abbey church in 1135. He accomplished the work in phases, beginning with the western entrance, the "westwerke," which was completed and dedicated in 1140, and continuing with the choir, dedicated four years later, in 1144. Though Suger had envisioned a reconstructed nave to complete the renovation, this section was not finished during his lifetime. Much has been written about the purpose, politics, and contribution of this rebuilding, but the comments that Suger and others have made on the intention of the reconstruction as it involves worship are my primary interest.

THE NEW SAINT-DENIS

On the entrance of the church, Suger instructed the crafts-person to inscribe the following verses:

> For the splendor of the church that has fostered and exalted him,
> Suger has labored for the splendor of the church.
> Giving thee a share of what is thine, O Martyr Denis,
> He prays to thee to pray that he may obtain a share of Paradise.
> The year was the One Thousand, One Hundred, and Fortieth
> Year of the Word when [this structure] was consecrated."[29]

Not only was Suger concerned about dating this achievement and claiming his role in it, but also he wanted to make its purpose clear. He elaborated in the following words inscribed on the door:

> Whoever thou art, if thou seekest to extol the glory of these doors,
> Marvel not at the gold and the expense but at the crafts-manship of the work.
> Bright is the noble work; but, being nobly bright, the work

[29] *Abbot Suger On The Abbey Church of St.-Denis And Its Art Treasures*, Edited, translated, and annotated by Erwin Panofsky (Princeton, NJ: Princeton University Press, 1946), p. 47.

Should brighten the minds, so that they may travel, through the
 true lights,
To the True Light where Christ is the true door.
In what manner it be inherent in this world the golden door defines:
The dull mind rises to truth through that which is material
And, in seeing the light, is resurrected from its former submersion.[30]

 Suger's intention is clear. He saw the art and architecture
of Saint-Denis as a vehicle for experiencing the inestimable
beauty of God. To be in touch with such mystery enabled
enlightenment and conversion. A splendid church provided a
form for participation in God's life. Suger's understanding
was influenced by the writings of St. Denis, the patron saint
of this church. For St. Denis, light, oneness and order were
symbols of divine presence. Light was the primary metaphor.
 In the teaching of St. Denis, God is uncreated Light. All
creation is a partial manifestation of this Light. Every creature
participates in the Light according to its rank in the hierar-
chical arrangement God has designed. As a dynamic symbol,
it is given by God and returned to God thereby setting in
constant motion the active participation of all creation. Since
light was such a significant medium for the presence of God,
the way in which it was manifested in the building was one of
the guiding principles for the reconstructed church. An em-
phasis on order and oneness was incorporated in the building
and in the liturgies at Saint-Denis as well. For Denis, and
therefore for Suger, the greater the unity, the greater and
more splendidly divine life was manifest. Each phase of the
building program reflected in a distinctive way this emphasis
on light and order.
 The "westwerke," the entrance to the church, was Suger's
first project. It was renovated not only to express the concepts
of light, oneness, and order but also to accommodate the
crowds that came on feast days. The entrance was expanded
to include a facade with two towers, three doors, a narthex
consisting of two bays, three aisles on the lower level and

[30]Ibid., pp. 47-49.

three chapels on the upper level.[31] The entrance introduced the contrasts of the building. It had very little light. Georges Duby describes it as "massive, compact, and dark, . . . [with] a military look."[32] In the opinion of some scholars, the design of the entrance to the church served a variety of purposes, satisfying both ecclesial and civil expectations. It conveyed the church militant and the authority of royal power at the same time.[33]

The dimness of the entrance established a stark contrast to the experience of the choir and the intended potential of the nave. The entrance symbolized life in this world with reality only partially seen, whereas the movement into the nave and choir expressed the glorious life beyond this world. As implied in the already-cited inscription on the door, the journey into the church paralleled a process of conversion, the movement from obscurity to insight, from the passivity of the womb to an enlightened participation, from the edge of belief through a threshold that concluded with a glimpse of the marvels of God. The entrance also included a rose window, the first of its kind found in the western facade of a church. Through it, light in a rich array of colors, filtered into the chapels, symbolic of the multifaceted essence of God experienced through light.

In contrast to the deep shadows of the entrance, the choir, distinguished by a series of stained glass windows at the eastern end of the church, was bathed in light. As Crosby writes "The celestial hierarchy, the realm of light, and the verities of sacred literature were given material existence."[34]

In Suger's mind, the light admitted through the windows was nothing short of "miraculous." "God has revealed Himself [sic] directly in the Incarnation, obscurely in nature and the metaphors of the Bible. We must grasp Him through these;

[31]Otto G. von Simson, *The Gothic Cathedral* (Princeton: Princeton University Press, 1974), p. 99.

[32]Georges Duby, *The Age of the Cathedrals: Art and Society, 980-1420*, trans. by Eleanor Levieux and Barbara Thompson (Chicago: The University of Chicago Press, 1981), p. 100.

[33]Crosby, 1981, p. 17.

[34]Ibid., p. 21.

we must perceive the divine light that illuminates them."[35] Used as the focus of liturgical celebrations, the design of this space conveyed visually what the liturgy intended to enact.

The characteristics of the medieval Mass had changed considerably from earlier celebrations of the eucharist. A shift of theological and ecclesiological emphasis had entered into the ritual. God was expressed less as one who identifies with us and more as an elusive, distant, mysterious God, One who transcended all humanness. Attention focused on the words and gestures of the priests, those who prayed in the name of the people, rather than on the active involvement of the people themselves. For example, during the observance of feasts, long elaborate processions of clergy (and royalty, if they were present) opened public celebrations with careful attention paid to social or clerical rank for the order of appearance. The people watched in awe, impressed and edified by the colors, textures, and movements of the participants. A sense of reverence and mystery permeated the entire liturgy. It was prayed in Latin, a language few people understood, including the clergy.

Polyphonic music sung by the choir limited congregational participation. Multiple ceremonial gestures, the placement of the altar in the midst of the clergy rather than the people, more and more infrequent reception of communion by the congregation—all these contributed to a distant and more personal/passive experience. Suger's reconstruction affirmed this kind of participation as normative.

The entrance to the church symbolized the reality of a world characterized by obscurity and the need for control. In contrast, the choir expressed the representation of heaven on earth, a preview of things to come manifest as perfect harmony, complete understanding and pervasive peace. Everything connected to the main area of the church, its environment, music, liturgical objects, and the conception of ceremonies, was designed to simulate an experience of transcendence. All choices about facets of the church's life were based on categories of the beautiful: "integrity or perfection, consonance of

[35]von Simson, pp. 120-121.

parts, symmetry, clarity, and luminosity."[36]

THE ART OF SAINT-DENIS

Suger kept his own records about the philosophy that shaped his attitudes toward the renovation of the church. Indeed, his attitude toward all forms of art was clearly formulated. Unlike his contemporary, Bernard of Clairvaux, who disapproved of art, "not because he did not feel its charms but because he felt them too keenly not to consider them dangerous, ... because it belonged on the wrong side of [the] world,"[37] Suger felt that more art rather than less was consistent with the essence of God. He considered it a grave sin to withhold any possible vehicle for experiencing God's life.[38] Simplicity and starkness, characteristics of Bernard's style, were inconceivable to Suger who favored the luxurious, the decorative, the sensual, and the beautiful. Every detail mattered. "For him the benediction of the holy water is a wonderful dance, with countless dignitaries of the Church, 'decorous in white vestments, splendidly arrayed in pontifical miters and precious orphreys embellished by circular ornaments,' walking 'round and round the vessel' as a 'chorus celestial rather than terrestial.'"[39] Whereas realistic art was forbidden by Bernard, it abounded at Saint-Denis in the embellishment of the portals, the stained glass windows, the altar, the decoration around crosses, and any place where it could be imagined.

Suger spared no expense in the decoration of the church. He required the finest materials: "golden vessels, precious stones, and whatever is most valued among all created things."[40] He insisted on talented artisans, whom he hired after an extensive search, not only to do the initial work but also to keep all of it in good condition through consistent repair and attention. Suger's concern for the beautiful ex-

[36]Crosby, 1981, p. 103.
[37]Panofsky, p. 25.
[38]Ibid., p. 13.
[39]Ibid., p. 14.
[40]Ibid., p. 16.

tended to every aspect of the church including the vessels, the frontal for the altar, and vestments. He insisted that respect for the liturgy required the best materials. Through these objects the divine order of the universe was perceived and established.[41] So convinced was Suger of the appropriateness of lavishness that he recorded a description of the church's ornaments, "lest Oblivion, the jealous rival of Truth, sneak in and take away the example for further action."[42] In such descriptions we find some hints regarding the importance of art in the liturgical life of the people.

Suger speaks about the decorations on an altar frontal:

> Into this panel, which stands in front of his most sacred body, we have put, according to our estimate, about forty-two marks of gold; [further] a multifarious wealth of precious gems, hyacinths, rubies, sapphires, emeralds, and topazes, and also an array of different large pearls—[a wealth] as great as we have never anticipated to find.[43]

In the spirit of the liturgical understanding of the time, Suger wanted to stress the action of the eucharist as mysteriously sacred, understood fully by no one, seen closely and enacted by only a few. The positioning of these gems symbolized the limited access of the majority of the people to the activity of the Mass. The ability to offer one's priceless possessions for use in the liturgy was an honor conferred to the most influential in the community. "Kings, princes, and many outstanding men, following our example, took the rings off the fingers of their hands and ordered, out of love for the Holy Martyrs, that the gold, stones, and precious pearls of the rings be put into that panel."[44] With these and similar actions, power, authority and precious possessions were identified with the expression and recognition of divine life.

Undoubtedly affected by political maneuvering, access to

[41]Crosby, 1981, p. 103.

[42]Panofsky, p. 53.

[43]Ibid., p. 55.

[44]Ibid.

the divine in a public setting was determined by one's place in a hierarchical ordering and by human achievements. Artists made their way into this hierarchical order by creating the artifacts used in the liturgy. Their fashioning and shaping was a direct contribution to the worshiping community's experience of the sacred. That they could participate so intimately in establishing the aura surrounding the eucharist was significant since these artisans had neither political nor ecclesiastical power.

Suger's description of the designs of the golden crucifix, the main altar, the altar for relics, the stained glass windows, the pulpit and the vessels followed a similar pattern to the frontal. In each instance, he employed the best artists to work with the most precious substances to convey the praise of God. Commenting on the main altar he says, "We profess that we must do homage also through the outward ornaments of sacred vessels, and do nothing in the world in an equal degree as to the service of the Holy Sacrifice, with all inner purity and with all outward splendor."[45] For Suger, opulence was necessary so that persons could be "transported from this inferior to that higher world in an anagogical manner."[46] For him the luxury invested in vessels and furniture was a vehicle through which even the most ordinary of mortals could participate more effectively in the mystery of God.

The extravagance that was characteristic of Suger's abbacy not only complemented his distinctive liturgical tone, but it also reinforced the power of the church and the monarchy. Ecclesial and political leadership were inextricably intertwined in Suger's lifetime in such a way that the same art and architecture which gave rise to an understanding of the glory of God played a similar role in respect to monarchy and to religious authority. Jane Hayward points out that the stained glass windows in the choir not only offer an interpretation of the relationship between the Old and New Testaments but "[they] magnified the role of the French monarchs as defenders of the faith and the abbey's own religious authority

[45]Ibid., p. 67.
[46]Ibid., p. 21.

as the repository of these most-sacred relics." [47]

From the work of the construction up to commissioning to regular ceremonial use, Suger had a singular focus at Saint-Denis: to reflect the city of God, a city whose existence was experienced most perfectly through extraordinary beauty and meticulous order, a city whose existence was modeled most exactly in ecclesiastical and political hierarchy, a city whose existence was known most vividly through reverential awe. The art and architecture as well as the ceremonies which were an extension or embodiment informing the commissioned works of Saint-Denis, made it possible to experience the city of God. "Art enabled man [sic] to grasp the substantive reality of the universe instantaneously, more perfectly than through reading and the mere seeing of things, more profoundly than through reasoning."[48]

ART AND WORSHIP AT SAINT-DENIS

The structure of the building integrally related to the needs and experience of the worshiping community.[49] Not only was there established a particular environment for worship, as described above, but also a tradition that both helps and haunts Christians to this day.

The Gothic structure of Saint-Denis attests to particular qualities of God and the divine/human relationship. It testifies to the magnificence of God, an abundance and a loftiness far beyond our ability to imagine. As a building that towered over other structures, the abbey church marked the distinctive identity of God, a source of unique power and authority. Unlike Dura-Europos, where the church building related to the everyday life of the people, the gothic design of Saint-Denis separated religious activity from the normal experience of the community. It represented the "otherness" of God through its size as well as its ornateness. The architectural

[47]Crosby, 1981, p. 65.

[48]Georges Duby, 1981, p. 77.

[49]Saint-Denis served as a model of the Gothic style for many subsequent church buildings.

style of the church and the theology that shaped the worship worked in perfect partnership. The mystery of God was embodied in both. Through the various tones of the space, the environment was an active participant in establishing an ambience for worship. It focused attention. It required formal, elaborate ceremonies. It enabled a ritual process. It offered a comforting space for prayer. It set aside the mundane concerns of hunger and poverty, of noise and squalor. The demands of the liturgy were met in an unprecedented fashion.

This collaboration between architecture and liturgy became more and more sophisticated. It required professionals for its activities. Clergy and musicians became actors in a staged performance. This situation reached extreme proportions in the sixteenth century, but even as early as Suger's time, the tradition was well established. Panofsky comments: "In arranging [the] processions, translations, foundation ceremonies and consecrations Suger foreshadowed the showmanship of the modern movie producer or promoter of world's fairs."[50] This style of worship responded to the spiritual needs of many people. Dramatic proclamations, great music, magnificent processions enabled them to feel the vitality of God.

The art of Saint-Denis, especially the figurative art also influenced worship. As in Dura, it stimulated memory and imagination and brought the concreteness of God's promises into contemporary demand and understanding. Scenes in the stained glass windows from the Old and New Testaments reminded the viewers of important moments in salvation history. Statues and other sculpture connected them with their Jewish and Christian roots. Panels of patriarchs, apostles and the old men of the apocalypse among others symbolized the "communion of saints" and reinforced the present community's participation in a church that extended beyond itself. These forms of art set the stage for a liturgy which attempted to reinforce these same concepts. Every liturgical action in the present was part of the past as well as the future. Every worshiping community was connected to those who had witnessed to God before them.

The figurative art may also have served to draw people into

[50]Panofsky, p. 14.

membership in the church, thereby enriching the local Christian community. As a public statement, the art in Saint-Denis signalled clearly a tradition of divine/human relationships that was transcendent yet real and comforting. The permanence of the art recalled God's faithfulness. It symbolized a commitment to a long term Christian engagement. Just as the ceremonies at Saint-Denis drew widespread attention, it is probable that the art likewise attracted many visitors, some of whom found the form of religious perspective attractive to them.

The art of Saint-Denis also bridged the gap between theological propositions and theological understanding. Words about the identity or function of God paled when compared to the experience of the divine at Saint-Denis. The unusual energy of the liturgical life made tangible the truth that God was beyond ordinary comprehension. Attention to minute details in every aspect of the church's life was a testimony to God's presence everywhere. The extravagance of ceremonies embodied the unparalleled and never fully explored variety of God's life with humankind. At the same time the asceticism of some of the figures, the playful light that streamed through the windows, the glorious music and colorful ceremonies of the Mass all contributed to a sense of the divine as dynamic, exacting, joyful, omnipresent and diverse.

The Community of Saint-Denis and the Contemporary Church

From the perspective of history, the art and architecture of Saint-Denis have expressed some precedents that have influenced the church's life to this day. The Gothic structure with a rose window in the western facade, exquisitely carved and decorated materials for ritual use and ornate ceremonies emphasized in the minds of many the magnificence and transcendence of God. This perspective has influenced ideas about what a church should look like and be. Many churches all over the world imitate this pattern, whether or not the materials are readily available or the style appropriate in a specific setting.

The tradition inherited from Saint-Denis also has had some negative effects. While not pervasive in every church and monastery of the time, the wealth and power manifested in the performance of the liturgy emphasized a role distinction that has taken centuries even to begin to undo. Those who had precious gems to contribute provided material for the vessels and other symbols. Those who held high places in government assisted at the altar. Royal and ecclesiastical privilege played a dubious part in determining one's participation in worship. This separation of the privileged from other worshipers undermined one of the unique functions of liturgical space, that is, to emphasize the dignity of each person regardless of economic, political, and social differences outside the church.

Class distinctions were further exacerbated by an evolution of roles assigned to the clergy and laity. Through the demands of ritual as well as an understanding of theology, clergy were increasingly separated from laity as another form of privilege. This isolation of various groups, one from the other, led to dominance and activity on the part of the clergy and to passivity and a retreat into private devotions on the part of the laity.

With differences in roles came changes in expectations. The liturgy was the exclusive concern of the clergy. They participated in the Mass by word, gesture, movements, vesture, eating and drinking. The laity were more and more removed from the central action and meaning of the liturgy. As a result, they developed auxiliary practices, reading their devotional prayers, singing hymns that had nothing to do with the content of the liturgy, and watching in awe when a bell rang to indicate something important was happening. Instead of receiving communion they participated often in spiritual communion, which was simply an intention and desire to commune but no actual eating and drinking. The laity could anticipate superb entertainment with the glorious sounds of polyphonic music and the splendor of processions and the beauty of the environment, but they could not anticipate active participation.

The arts played a major role in supporting these qualities of the liturgical life at Saint-Denis. While the movement that

supported this interaction was well under way before Suger's abbacy, he was a major factor in insuring its permanence. His determination, love of art, intuitive judgments, and theological interpretations in addition to his enormous influence with the monarchy contributed substantially to the continuing development of the arts at Saint-Denis.

The worshiping communities of Saint-Denis and Dura-Europos offer contrasting situations for our examination of art and worship. Dura-Europos was a community with a short life. The church of Saint-Denis was begun in the eighth century and continues to function today. Dura was the victim of political clashes, Saint-Denis the victor. Dura represented a synthesis of many cultures, Saint-Denis is typically French. Dura's primary concern was the development of a Christian comunity. Saint-Denis' goals are mixed: the life of its own liturgical community, its public image, and its relationship to the royalty. Dura's short history was relatively unaffected by Christian controversy. Since the church of Saint-Denis spans centuries, its life moved rhythmically in response to the demands of church and government. Dura was a people's church. In keeping with the medieval world view of the Middle Ages which allocated unilateral power to the designated ecclesiastical authority, Saint-Denis, during the years described (1122-1151), was literally Suger's church. All decisions about its life were by Suger, the Abbot of the Benedictine community in residence. The circumstances in each of these situations influenced significantly the incorporation of the arts as an integral part of worship. Not unimportant among their considerations was the shape of the belief of the community, the needs of the church, the larger societal context in which the church existed and each congregation's understanding of the potential of art. Affected by politics, history, theology, artistic and liturgical perspectives, the results were dramatically different.

In this century and the next, liturgical challenges will continue to emerge from the historical context in which the church exists. They will arise also from the development of theology, which is already raising questions about many central doctrinal issues, such as the interpretation of Christology or the meaning of the Trinity. Changes in artistic expres-

sion will add other complexities to what the church can anticipate. Electronic sounds, the use of film and abstract art will nudge communities to new insights, feelings, and ideas. Within these challenges lie both the problems and the potential for creative artistic solutions. The stories of the churches of Dura-Europos and Saint-Denis offer certain clues for the present and the future. While it is not appropriate to imitate them, it is crucial to learn from them. Given the pivotal role of history in their artistic choices, our search for an adequate framework to utilize art within worship more fully in this century will begin with an analysis of the needs of the church today.

2

An Evolving Tradition: Listening to the Church

The twentieth century, marked by a succession of world wars, economic upheavals, complex global relationships, and sophisticated technological and theological developments, has added new concerns for all religious communities. In addition, the potential for nuclear devastation, the unstoppable spread of Aids, the persistence of hunger in a world that produces plenty, the threat of and involvement in war, the overt and subtle expressions of class, racial, and sexual discrimination, and other examples of greed unleashed with power are critical concerns touching today's churches.

The liturgy is not an isolated event which can be separated from such concerns. Its celebration must connect with all the areas that relate to human reality. Ways in which to express these concerns require courage, honesty, sensitivity and imagination. The arts are a resource for this task. In this chapter I will focus on characteristics of the church that are requisite today in light of our history, and the liturgical needs that follow from them.[1] This discussion will anticipate an examination in Chapter Three of ways in which the arts can help to meet these needs.

[1] The experience that gives rise to this discussion is primarily from within a North American context. There is no pretense that these words will provide an omnibus view of the church. The goal is to *stimulate thinking* about the church that has some direct relationship to its liturgcal practices. A variety of conclusions can then be drawn.

The Contemporary Church

Throughout the twentieth century, the church has not stood aside or stood still in the face of urgent needs. Some church communities have turned inward, or away from any confrontation, while others have expanded their embrace. The difference in the choices of these Christian communities is significant. It affects stability, economic solvency and influence. Those for whom change is inconsistent with the mandate of the Gospel and who, therefore, have chosen a carefully bounded and controlled movement seem, from some perspectives, to have prospered. Those, on the other hand, who consider change as a natural outcome of the search for truth have risked insecurity. Their experience validates the observation that change brings upheaval. What Toynbee says of nations is equally true of churches:

> A young nation is confronted with a challenge for which it finds a successful response. It then grows and prospers. But as time passes, the nature of the challenge changes. And if a nation continues to make the same, once-successful response to the new challenge, it inevitably suffers a decline and eventual failure.[2]

Churches make conscious choices to envision and adopt innovative responses to personal and social needs as they discover that well-rehearsed formulas no longer are appropriate. At this time in history when greed, power, and dishonesty are unleashed in such overwhelming doses, religious communities need to speak and act. When churches assume responsibility for the situations that exist in society, such awareness will affect their liturgical celebrations. They require critical thinking, constructive ideas, collaborative models, compassion, and courage. A few words about each of the characteristics will set the tone for a discussion of the liturgical needs of such contemporary churches.

[2]Rosabeth Moss Kanter, *The Change Masters: Innovation and Entrepreneurship in the American Corporation* (New York: Simon and Schuster, A Touchstone Book, 1984), p. 17.

1. Critical Thinking

Critical thinking begins with the structures and choices of the church itself. The development of the church depends in part on its ability to look backward and forward regularly. Analyzing the past enables it to identify both the bad and the good in its practices: inconsistent priorities, inefficient use of resources, apathetic membership, as well as choices and commitments that reflect its prophetic and priestly qualities. Such constant attention to its life is crucial because the church proclaims an incarnational theology as its central teaching. God who is beyond containment became human. In this act God united the human with the divine and invited all human beings to embody this relationship after the example of Jesus. Since the reality of God's reign among us was not a onetime experience, but a model for succeeding generations, the church is required to reflect consistently on its faithfulness to the witness of Jesus' vision.

The study of the New Testament has convinced biblical scholar Raymond E. Brown of the need for a posture of self-criticism within the church. " ... a frank study of New Testament ecclesiologies should convince every Christian community that it is neglecting part of the New Testament witness."[3] Brown refers here to the multiple models of Christian commitment described in the New Testament, some in tension with others. He suggests that because the diversity is so complex, it is unacceptable for any community to draw conclusions about their own traditions that do not presume constant study of scripture, a study that could require change. A more faithful reading of the Bible, Brown argues, will demonstrate that God is asking more than any one Christian community has heretofore heard or identified.[4]

In today's church, where self-righteousness can be only too prevalent, self-criticism involves acknowledging the church's own deficiencies: its discriminatory policies, its class preferences, its sexism, and its subtle condescensions. It requires

[3]Raymond E. Brown, S.S., *The Churches The Apostles Left Behind* (New York/Ramsey: Paulist Press, 1984), p. 149.

[4]Raymond E. Brown, p. 150.

establishing a process for their correction. It begins by listening to opinions different from the dominant ones in an attempt to find truth from other perspectives. In this process, it will anticipate its limitations and acknowledge its power. As it attempts to interpret the meaning of significant events in the lives of its people, it will be modest in its claims, yet unrelenting in seeking ways of witnessing to the causes and the effects of injustice and of working for change in these circumstances.

In addition to self-criticism the church is called to take its distinctive understanding beyond itself. The influence of religious witness has historically permeated societies of all nations. Today's society is no exception. The church's responsibility is to act in the name of truth where it sees and experiences it. Robert McAfee Brown shows that biblical interpretation is an important factor in our assessing our activity. How we read a text affects our response to it, whether from the position of people with power or as people who live at the whim of those who have that power.[5] Brown illustrates with familiar biblical stories which reveal a "political" God, a God who is not neutral but clearly takes sides. He points to texts that challenge an uncritical acceptance of authority. For example he sees in the story of Nathan and David (2 Samuel 11:2-12:7) a clearcut illustration of someone who challenges the highest authority of the land.[6] In a later book, Brown presses the biblical/political question even further. He sees in passages of the biblical text warnings about idolatry that apply to present situations. He challenges the church to identify publicly those situations when an individual or nation appropriates to itself the power of God. "The process of saying Yes and saying No is one of sorting out what is really to be rendered to God and what is left for Caesar. And when Caesar begins to act more and more like god (a false god), the need for discrimination between God and Caesar takes a quantum leap."[7] The biblical text unabashedly claims that

[5]See Robert McAfee Brown, *Unexpected News: Reading the Bible With Third World Eyes* (Philadelphia: Westminster Press, 1984).

[6]Ibid., pp. 49-62.

[7]Robert McAfee Brown, *Saying Yes and Saying No: On Rendering to God and Caesar* (Philadelphia: Westminster Press, 1986), p. 15.

allegiance to God supersedes any other. It requires the church to hold individuals and nations accountable for the substitution of a rival god.

A critical church is unwilling, either for itself or for others, to settle down to things as usual. It is alert to the possible disjuncture between the mandates of scripture and the realities of human experience, ready to call attention to this discontinuity. It is not unmindful also of its tendency, like any other institution, to make the easier but dishonest choice, i.e. to remain silent or neutral. It recognizes that it is not credible to proclaim a gospel of freedom and at the same time to disregard human situations in its neighborhood or in the world where its members or any other human beings are denied basic rights. It is not credible to announce a gospel of love and not work against those situations where people are buffeted daily with hate or are without a secure home and food. A critical church will identify the gaps between what it says about human freedom and what it does to insure it. Critical thinking is the first step in a succession of challenges the contemporary church faces. However, it is not enough to identify the situations that need our attention. The church is called to offer constructive ideas that will constitute a basis for change.

2. Constructive Ideas

As an organization whose values often do not coincide with prevailing positions and powers, the church's membership is called upon to keep its own vision fresh. Shifting contexts alter the way in which the church's texts and life are experienced. Its vitality depends on its ability to meet new needs. Anne E. Patrick, a feminist theologian at Carleton College, offers an example.

In an article addressing the changing perceptions of what constitutes an interpretation of values and virtues she points to the conflict between two existing paradigms. The first is patriarchal, one in which power is maintained through dominance, and where superiority is determined by reason of gender and social status. The second is egalitarian, where

power is understood as "the energy of proper relatedness" rather than "control over." In this paradigm, responsibility for power is shared equally.[8]

Much of the evil that exists within the churches and in present societal structures is attributed to a patriarchal paradigm. Power and decision making have been the prerogative of men. The isolation of ethnic men and all women has deprived our institutions of untold energy, insights, and experiences. Educators, sociologists, biblical scholars, theologians, historians, and members of religious communities among others have pointed out the implications of destructive patterns of dominance. They offer constructive models for change.

As an institution that provides ongoing guidelines for an application of its truths to everyday life, the church participates in a never-ending process of pruning. The present awareness of the systemic evil the patriarchal system has perpetuated is one example within its own life which needs to be excised and replaced. The situation calls for constructive proposals that acknowledge the awareness of its current membership.[9]

3. Collaboration

The resources for a critical and constructive church are found primarily in the collaborative strength of its members. The earliest record of the description of the Christian church reports such an interdependent life. Everything was held in common, goods were distributed evenly and the prayer and witness were the responsibility of every person (Acts 4:32-35). Clearly in the first Christian communities the crisis sparked by the death of Jesus and the survival of the church forced the

[8]Anne E. Patrick, "Narrative and the Social Dynamics of Virtue," *Changing Values and Virtues*, Concilium 191(1987), ed. Dietmar Mieth and Jacques Pohier, pp. 72-73.

[9]For further discussion see "The Challenge of Change" by Arthur M. Schlesinger, Jr., *New York Times Magazine*, July 27, 1986, pp. 20-21 and Paul R. Lawrence, "How to Deal with Resistance to Change," *Harvard Business Review*, Vol. 46 (January-February, 1969), pp. 4-13.

members to depend on one another.

Today, the crises that affect survival among Christians are demanding similar solutions both in local communities and on a global scale. No nation or religious group can effect the changes required to insure freedom for all people. The power found through collaboration is critical. Examples abound: in poverty-stricken communities people band together to fix an apartment house or to badger the local government for environmental improvements; workers organize to demand just wages and conditions; people gather in rallies to make public statements about war and about peace; women resist arrest or expulsion by avoiding isolation and instead stand together persistently. Often change in any significant aspects of public life depends on collaboration. The support of each other is a powerful force for the radical transformation of oppressive structures within and beyond the church.

Though the survival of the twentieth century church is not threatened with extinction as it was in the early centuries, nor is it driven to change by a miserable quality of life, nevertheless the church is affected deeply by the inevitability of what must be named unnecessary death all around it. Disease, hunger, the denial of human rights, and the potential for nuclear annihilation of the world can be eliminated through cooperation both within the church's structure and in its prophetic relationship to other institutions.

4. Compassion

The work of collaboration, supported by critical thinking, and constructive ideas is most effective when it is accompanied by compassion, an identification with those who are suffering.

Compassion means literally, to suffer (*pati*) with (*cum*) others, to participate in the pain of others with genuine understanding. A world that is so deeply divided—nation from nation, group from group, person from person—cries out for compassion, compassion that extends not only to a process of reconciliation spanning months or years, but also to the immediate pain every person endures. All of us need compassion: those who are economically and emotionally poor,

those who are confused by conflicting values, those who are old or sick and feel no reason to continue living, those who are oppressed, both those committed to non-violence and also those pressed to violence, those who are isolated, burdened with loneliness, those who are unloved with no hope for any change. Sympathy is not enough. Unlike death, these situations can be changed. Nor is pity adequate. Too often pity implies superiority rather than solidarity. The world needs to feel divine compassion mediated by humankind that touches every aspect of human life.

In a sermon preached after the death of his twenty-four year old son, William Sloane Coffin described in a personal way the depth of one person's pain and the need for compassion within the community of the church. Coffin resisted categorizing Alex's death as the "will of God." He corrected this response saying: "My own consolation lies in knowing that it was *not* the will of God that Alex die; that when the waves closed over the sinking car, God's heart was the first of all our hearts to break."[10] God is not an all powerful deity who sits idly by "watching" pain, or tragedy, the murders of races, the physical or emotional deaths of any people, innocent or guilty. God laments injustice, greed, war. The church, as the visible extension of God's life, is charged to embody the unlimited and unbiased compassion of God. It is called to suffer with any one in pain, whatever that pain may be. Robert McAfee Brown reminds us that this command includes even what may seem insignificant or at least unimportant: "concern for the trite, the drab, the banal, the unmagnificent that characterizes Scripture and the God of Scripture."[11]

5. Courage

For the church to be engaged in critical thinking, constructive envisioning, as well as shared and compassionate tasks requires courage. Our responsibilities as a church in this era

[10]William Sloane Coffin, "Alex's Death," sermon preached on January 23, 1983 at The Riverside Church, New York City, p. 2.

[11]R.M. Brown, 1986, p. 51.

are awesome. First, the churches' concern extends to the whole inhabited earth, its people, and all its resources. Second, as an organization whose values are determined by a vision of love and faith rather than recongition and wealth, its goals often will conflict with those of other powerful institutions.

Today courageous acts of resistance abound within the church. The choice of some Christian communities to offer sanctuary to people from Latin American countries conflicts with the position of the United States government. As a result church representatives involved in this project are accused of breaking the law. Government agents remind us that such actions are cause for possible imprisonment. Yet, individuals and groups persist in offering a safe refuge.

Religiously motivated individuals and groups in South Africa and in Korea daily face the reality of death and imprisonment for their challenges to the positions of prevailing governments. Groups in many countries who persist in antinuclear organizing are constantly threatened and harassed. Church and governments around the globe are in serious confrontations. The continuation of their work demands extraordinary courage.

A similar spirit of courage is often required within church bodies themselves as power struggles persist over the interpretation of church doctrine and structures. Members who challenge the status quo and call for creative change are threatened frequently by the accusations of institutional authorities. It takes real courage to hold a minority position over and against the power of the ecclesiastical tradition.

The contemporary church demands courage, not because persecution and death are new to it. These characteristics are evident throughout its tradition. The witness of Jesus is an unrelenting testimony: "I came into the world for this: to bear witness to the truth; and all who are on the side of truth listen to my voice" (John 18:37). Today, as citizens of a fragile and interdependent planet, we struggle for truth. We understand more clearly and consistently our collective responsibilities for the persecution and death that persists. To change what one sees and feels requires faithful courage.

Liturgical Needs of the Contemporary Church

The challenge to today's churches must be embedded in their liturgical life. That challenge is to live courageously with compassionate and critical stances toward the realities of social and personal life, and to be concerned with the constructive and envisioning work to which the Gospel calls us in collaboration with our neighbors, at home and abroad. In the liturgy, where the church's theology and mission is expressed and understood, the principal motivation for pioneering change will be found.

Some church members come to Sunday services expecting comfort. Traditionally, these needs have been met through predictable structures for prayer, singing, and participating in communion in addition to hearing the scripture read and preached. By way of these forms, members felt the sense of a *transcendent deity,* and some *connection* with each other. They experienced *beauty, affirmation* of their own lives and support for *faithfulness.* It is possible to trace these characteristics of liturgy throughout history. However, the ways in which they are conveyed and therefore known must change to meet contemporary needs.

1. Transcendence

In light of the emphasis in this book on the importance of the connection between liturgy and the realities of human experience, a decision to begin with the need for *transcendence* could be considered unlikely. However, it is precisely because of the connection that the need for transcendence is so significant. Acknowledgment of a divine being whose mercy, goodness, and love are beyond human comprehension is indispensable in the contemporary church where life together is inevitably affected by the evils of greed, oppression, and exploitation.

Worship, the confession of a divine/human relationship, is the symbol of a faith that reaches beyond immediate realities while being at the same time connected to them. Since worship symbolizes more than can be fully grasped, it requires an

environment that includes more than casual interactions. In the past, the experience of transcendence has been identified with a variety of expressions: splendor, soberness, formality, and special symbols, like sacred music, distinctive architecture, characteristic gestures and objects set aside particularly for liturgical use. These expressions emphasized the otherness of God, a God separated from the experiences of everyday life. They inspired awe, evoked mystery, and formed the basis of the church's thanksgiving. This expression and meaning of transcendence is no longer enough.

In a time when tragic accounts overwhelm the pages of every daily newspaper, authentic liturgy will reflect a theology that addresses the divine involvement in these situations. While in the Christian church the theology of the cross and resurrection of Jesus has always been the central metaphor for liturgical experience, the concrete connection between a transcendent God and those people caught in the web of pain, death and frustration is not always obvious. Sounds, words, and gestures that transport a congregation temporarily into another world are not sufficient when tragedy is pervasive. We need forms that will connect the revelation of God with the most poignant needs of the people who constitute the church.

The liturgy is "an action wherein the testimony of God is heard and appropriated, the experience of the community is transformed, and a godly presence disclosed," writes David Power.[12] If this is true, then the Christian community must be able to count on a divine/human experience, consistent with a God of mystery, which articulates the continuing pain, frustration and despair of people in our world. A God who chose to become human has already signalled involvement with human life, especially identification with those who are suffering.

The articulation of divine participation in human agony is irretrievably intermingled with the transcendence of God. It connects the "disclosure of God" with the real experience of the human community. Insofar as humanity suffers, God

[12]David N. Power, O.M.I., *Unsearchable Riches: The Symbolic Nature of Liturgy* (New York: Pueblo Publishing Co., 1984), p. 146.

suffers. In that articulation the community discovers more concretely the relationship of mutual faithfulness inherent in the commitment to God and to one another. This relationship expresses itself in "lamentation" as well as "thanksgiving"[13] in a passion for justice[14] as well as in the promise to love.

The fullness of the mystery of the church and of God may elude us, but the church's primary clue to unraveling this mystery—the life of Jesus—convinces us that compassion is connected with transcendence. Liturgical expressions must reflect the awareness and attentiveness of a God whose transcendence includes participation in the grief and incomprehensible suffering of human beings. God waits with humanity for the fulfillment of a vision where hate, greed and injustice will be eliminated and where, in their place, all human beings will have access to the fullness of life.

2. Connection

The prophet Amos set a sober context for the celebration of our worship:

> I hate and despise your feasts,
> I take no pleasure in your solemn festivals ...
> Let me have no more of the din of your chanting,
> no more of your strumming on harps.
> But let justice flow like water,
> and integrity like an unfailing stream. (5:21-24)

Worship characterized solely by transcendence is not enough. The liturgical renewal of this century was sparked by the need to adapt the liturgy to contemporary culture. Few envisioned the magnitude of the task to which this need for connection calls the church.[15]

Within the liturgical renewal there has been a dedicated

[13]Ibid., p. 167.

[14]See Carter Heyward, *Our Passion for Justice: Images of Power, Sexuality and Liberation* (New York: The Pilgrim Press, 1984).

[15]Power, pp. 5-34.

commitment to understand the meaning of the earliest Christian liturgies. Attention is given to words and gestures as they shape the intention and form of the celebration. Some scholars suggest that the closer the modeling of contemporary celebrations is to the earliest ones, the more expressive they will be of their purpose. However, the need of the church to make connections between historical experience and an ageless ritual is sometimes lost in the race to uncover ancient practices. David Power reminds us that the contemporary church should be aware of a tendency to retreat into the past or succumb to abstract universalism. He cites the lack of a *liturgical* response to the *Holocaust in Germany* and to the *threat of a nuclear holocaust* as examples.[16] The church must be aware constantly of the connections between worship and historical events, of cultural as well as theological developments.

Recently a number of scholars have addressed themselves to the specific relationship between worship and these two holocausts.[17] Johann Metz writes: "There is no truth for me which I could defend with my back turned toward Auschwitz. There is no sense for me which I could save with my back turned toward Auschwitz. And for me there is no God to whom I could pray with my back turned toward Auschwitz."[18] These scholars agree that the Holocaust, as an unparalleled experience of the absence of God, demands more notice than it has received. It is an event of Christian history which the church has not claimed. That it happened is the responsibility of all people and must be acknowledged liturgically. "Is it too strong to suggest that our liturgy will remain inadequate, will continue to turn its back on fact, as long as it is conducted in such a way that gestures, verbal images, vestments, and other

[16]Ibid., p. 2.

[17]See John T. Pawlikowski, "Worship after the Holocaust," *Worship*, Vol. 58 (1984), pp. 315-329; Lawrence A. Hoffman, "Response: Holocaust as Holocaust, Holocaust as Symbol," *Worship*, Vol. 58 (1984), pp. 333-341; and Gordon Lathrop, "A Rebirth of Images: On the Use of the Bible in Liturgy," *Worship*, Vol. 58 (1984), p. 300.

[18]Johann Baptist Metz, "Facing the Jews: Christian Theology after Auschwitz," *The Holocaust as Interruption*, Concilium 175 (1984), ed. Elizabeth Schüssler Fiorenza and David Tracy, p. 28.

liturgical accoutrements bespeak Christ in his glory and majesty, while, if the truth be faced, the Christian community is living right-smack-dab in the middle of Holy Saturday."[19] To overlook the implications of the two holocausts in the form and content of the church's worship is to deprive the majority of the Christian community of the potential which worship offers for understanding and judging the implications of these historical events. The two holocausts are an example of one important connection that must be made.

Connections with theological development are also important in our experiences of worship. One controversial example is the naming of God. While throughout Christian history, theologians have decried any final word on the imaging of God, many aspects of the church today continue to maintain that some words are essential and irreplaceable. Some contemporary theologians are addressing this perspective, pointing out that confining God to any particular name or image is idolatrous.[20] Critical theologians argue that since the church accepts the incomprehensibility of God, nothing more specific than metaphors can describe God and no single metaphor can bear the entire burden. Feminist theologians specifically point to the primary use of words such as Father, Lord, and King. Not only are Lord and King "caste" terms and as such are inappropriate, but all three are examples of placing limits of maleness on the image of God. Their exclusive emphasis denies the ability of females as well as female terms to convey the experience of the divine.

Theologians concerned with liberation also question adjectives describing God. They question the authenticity of the use of all-powerful, and almighty in the face of the absence of God or the tolerance of God for cruelty, excruciating suffering or blatant injustice. Such realities make these metaphors inappropriate at best and more often simply inaccurate.

Similarly, theologians are raising important questions about images that equate light with good and darkness with evil,

[19]Michael Downey, "Worship Between the Holocausts," *Theology Today*, Vol. XLIII, No. 1, April 1986, p. 81.

[20]See Rosemary Radford Ruether, *Sexism and God-Talk: Toward a Feminist Theology* (Boston: Beacon Press, 1983), pp. 22-23.

and those that continue the traditional dominance of master and slave. These racial stereotypes no longer serve to enhance our understanding of God and our relationships with one another. The cultural context in which they were acceptable has changed. Our contemporary consciousness of racism and classism makes them offensive.

Church members grasp for real connections between their worship experience and their lives. These examples are some of many which emerge from changing perceptions, developing cultural patterns and political/economic systems. It is imperative to reflect these shifts of contemporary life in the church's worship.

3. Beauty

Within the context of worship, beauty is most often associated with music, architecture or ceremonial aspects of the liturgy. It is connected with what is pleasing, lovely, or harmonious. Beautiful experiences, often enabled through the work of artists, are important. They are glimpses of fullness, of possibility, of God. They point to a reality the church seeks to encounter and embrace.

However, the definition of beauty comprises more than what is pleasing. It also includes what is *truthful* and what is *original.* These latter interpretations are critical to a discussion of beauty within worship because the liturgy expresses pain, frustration and struggle as well as the promise of fullness of life. Beauty is found in both the unpleasant and the pleasant. As Eugene O'Neill writes "I don't love life because it's pretty. I am a truer lover than that. I love it naked. There is beauty to me even in its ugliness."[21] Taking for granted the need of the contemporary church for loveliness, harmony and what is pleasing, we turn our attention to two further aspects of beauty.

[21] Eugene O'Neill, *Dial,* a magazine of WMHT, September, 1986, p. 34.

Beauty as truth

Within the experience of worship, beauty defined as truth is frequently experienced in the connection between symbols and the realities of human life. One poignant example is the Cuzco cross created in Peru. It features a human figure with disproportionately large hands and feet nailed to the cross, a contorted body through which one can feel the howling, the anguish, the agony of a human being whose body is stretched beyond its limits. The symbol is an attempt to connect concretely the redemptive activity of Jesus with the plight of the laborer whose working conditions stretch the capability of the human body beyond its limits. The beauty of the cross is in the truthfulness of the connection between the reality of this particular human experience with both the agony of Jesus and the power for change symbolized in the cross. It has nothing to do with being pretty.

Truth is embodied in the narratives of people as well. It is reflected in the stories of ordinary people who live in extraordinary ways: those who work tirelessly for freedom, those who spare nothing to insure justice, those who persist in loving despite overwhelming obstacles. Truth is given tangible form when there is a consonance between what one understands and a response to that reality. The diary of Etty Hillesum, *An Interrupted Life,* is one example. Surrounded by the greed, hate, and prejudice of Nazi Germany, Hillesum persisted in her belief that a different future was possible. "Let me use and spend every minute and turn this into a fruitful day, one stone more in the foundations on which to build our so uncertain future."[22] Ordinary women and men are extraordinary symbols of divine life. They unveil beauty when it is hidden, restore it when it is defaced, create it when it is nonexistent.[23] Beauty persists, Robert McAfee Brown writes, "in the midst of oppression, . . . [and] despite oppression." It is "beauty that not even oppression [can] liquidate."[24] Truth-

[22]Etty Hillesum, *An Interrupted Life: The Diaries of Etty Hillesum, 1941-1943* (New York: Pantheon Books, 1983), p. 52.

[23]Robert McAfee Brown, *Creative Dislocation: The Movement of Grace* (Nashville: Abingdon Press, 1980), p. 142.

[24]Ibid., pp. 69, 70.

fulness conveys such beauty. In the midst of a time when persecuted people outnumber those who are not, the church looks to examples of truthfulness that testify to the beauty of God.

Beauty in originality

Beauty as truth is aligned closely with beauty experienced in what is original. Both are embodied in the distinctive contributions of an individual or community. Originality is associated particularly with the behavior, work, or relationships of people who express uncommon perceptions. Artists and inventors lead a list of individuals who relentlessly pursue a creative expression of their own ideas. However, not only these specialized persons but also others express the beauty of originality. For example, people who envision new patterns of working, such as laborers who share jobs or become owners rather than give up the industry in a particular location; those who risk new models of relationships, such as single parents or couples of the same sex who adopt unwanted children; those who inject new ideas into tired discussions, such as academics who envision a change in teaching methods or curricula, challenging traditional ruts. These people are responding to a situation from their own experience that stretch conventional expectations and limits. Their exposure of beauty is much deeper than superficial appearance.

Originality is intimately connected with the nature of God. From creation and redemption to the pervasive but unpredictable presence of the Spirit, God acts in unimaginable and original ways. Human beings reflect this divine capability. When applied to liturgical practice, originality is expressed in fresh insights, evocative images, energizing architecture and environments, spirited music, forms that are on the cutting edge of acceptability. Old answers do not satisfy new questions. Worn out clichés strain the limits of commitments. Worship requires beauty which anticipates a spirit of adventuresomeness and openness as a witness to the uncharted ways of God.

Beauty in all the aspects of its definition can be elusive. To notice it demands imagination and participation. However,

when identified the impact is irreversible. It is an experience beyond words that touches the most profound recesses of our beings and awakens us to a world beyond our daily grind. It invites affirmation both divine and human.

4. Affirmation

In today's church people need affirmation: we need to feel God's affirmation of our human condition, and we humans need to applaud the worth of other human beings and to delight in God. In the midst of crises which seem insurmountable, even so apparently small a gift as affirmation helps. Yet so often the institutional church is too concerned about its own internal interests to express or even allow within its liturgy concrete expressions of divine and human affirmation. It indulges an undue preoccupation with promulgating doctrine, with the faultless propriety of ritual practices, or even with avoiding a certain breezy familiarity such as occurs in the "passing of the peace."[25] With such precautions the church loses a shining opportunity within regular worship to ritualize divine and human affirmation.

Affirmation can take many forms. The choice of what is appropriate depends on particular needs. However, it is important to make clear that it does not imply an endless stream of acknowledgments of individuals' successes or even sorrows or prayers that go on interminably. Rather it is an attitude about worship which pervades the entire experience. It is a willingness to engage the symbols so that they can express their contrasts in such a way that they connect with everyday life. For example, when a woman says in the midst of the breakup of her marriage that she cannot participate in worship because it's too joyful, something essential is missing in the use of the symbolic language. One hears the same response to funeral liturgies that stress the resurrection theme to the exclusion of the loss that the congregation may indeed be feeling. While in general the church has often been accused of

[25]In some churches there is no "passing of the peace" because the leaders of the church fear that the practice will degenerate into a casual, social exchange instead of a sharing of Christ's peace.

soberness rather than joy, its members are calling for a recognition of their human experience as a contributing factor in the shaping of religious rituals. This attempt at connection is one kind of affirmation needed. It replaces isolation with presence, untended pain with compassion, and short-lived rejoicing with long-lived courage. Affirmation is difficult at times, especially when the circumstances of some people's lives are so radically different from one's own. In these situations particularly, the community depends on faithfulness, born of pain, nurtured in ambiguity, and dependent on divine response and initiative.

5. Faithfulness

In a contemporary church for which evaluation and renewal are an integral part of its life, faithfulness must not be interpreted as blind adherence to proclaimed truths, unquestioning loyalty to institutional authorities, nor grim determination to stay with something just as it always was. Rather faithfulness is identified as believing in a human/ divine relationship that extends beyond our expectations and often beyond our understanding, one that is intertwined inextricably with mystery, questions, and surprise.[26]

In a church where forms, formulas and constituencies are shifting rapidly, within a culture where the terms of personal commitments are changing radically and in a world where God is no longer considered omnipotent or "in control," a faithful church is one characterized by imagination and tenacity. It is not fixated on one way as the only interpretation of a covenant relationship, nor is it willing to surrender easily the freedom such a relationship offers. Rather it insists on contributing its own understanding as part of the ongoing revelation of divine/ human commitment. Elie Wiesel explains such persistence from the perspective of the Jewish tradition:

[26]For an insightful discussion of faithfulness see Margaret A. Farley, *Personal Commitments: Beginning, Keeping, Changing* (San Francisco: Harper & Row, 1986), pp. 38-53.

There were many periods in our past when we had every right in the world to turn to God and say, "Enough. Since You seem to approve of all these persecutions, all these outrages, have it Your way: let Your world go on without Jews. Either You are our partner in history, or You are not. If You are, do Your share; If You are not, we consider ourselves free of past commitments. Since You choose to break the Covenant, so be it."

And yet, and yet ... We went on believing, hoping invoking His [sic] name ... We did not give up on Him ... For this is the essence of being Jewish; never to give up—never to yield to despair.[27]

Faithfulness in the contemporary church requires similar perseverance. The Jews have taught us a profound lesson. Faithfulness is difficult. It has few romantic edges. It can involve incomprehensible pain. Sometimes it is solitary, with little tangible support. However, as Wiesel also reminds us, the tradition which each life continues and of which each is a part provides a connection that supports faithfulness. "We owe it to our past not to lose hope.... Three thousand years of history must not be permitted to end with an act of despair on our part. To despair now would be a blasphemy—a profanation."[28]

Liturgically, faithfulness begins with an honest acknowledgment of the context in which the church celebrates its faith. When people are overwhelmed by oppression, by meaninglessness or helplessness, a faithful church identifies ways in which its texts and the texture of its life addresses those situations. The most obvious examples, though not the only ones, are the movements for the recognition of human dignity and all its privileges for persons of all colors, races, classes. The role of the church in insuring this freedom is constantly unfolding. Some examples are the struggles for the rights of blacks, the poor, and the marginalized where the church assumes leadership in challenging and overturning

[27]Elie Wiesel, *A Jew Today* (New York: Random House, 1978), p. 164.

[28]Ibid., pp. 166-167.

systems that perpetuate such evil. In its liturgies, the church speaks of courage, persistence and hope. It embodies compassion, as well as determination. It stands for life while recognizing that such identification requires death. It models new possibility at the price of the numbers in its membership, the prestige of its name, or its own security. The liturgy is a concrete expression of the pilgrimage of Christians in this century. The liturgical action is a response to it in light of the covenant with which it is identified.

Not only must the faithful church include the wider cultural context as a necessary ingredient in its liturgical celebrations, but also it must look within itself for clues to shape them. Are there voices within its membership speaking about needs that have long been unrecognized or that have emerged as a result of new understanding in this century? For example, in the Roman Catholic Church, where minority groups have, at best, a token voice, many Catholics can no longer accept an antiquated view of the responsibility of their church membership. Their faithfulness demands that they look with a fresh perspective at the terms of their membership. Liturgical patterns express the contract the church shares with God and with each other. As it unfolds so too the liturgy changes. Often voices within the church are muted by institutional authority. Faithfulness is again imaginative and persistent in finding ways to continue despite resistance, or threats, or even institutional excommunication. Faithful people do not surrender their membership because of institutional blindness. Rather they continue recognizing and working with that blindness. Faithfulness defies intransigence, superiority and apathy. It offers an alternative voice: a celebration and acknowledgment of a relationship with God that identifies present realities as the working context for its commitment.

The response of many women is a good example of such faithfulness. While their experience of God and of society is not included in the liturgical expression of many churches, they find other ways to support their faith. They design liturgies that embody women's journeys, they reclaim interpretations of symbols that include female experience, they encourage leadership as yet unrecognized in the wider church. They await the day when their experience will be acknowl-

edged, but they do not wait passively. Rather, believing in a God beyond institutional restrictions whose first principle is love, they persevere courageously and confidently to respond to insights which respect their dignity as full partners in the covenant with God.

Perhaps faithfulness has not been an easy commitment in any age. However, in this contemporary time, it seems peculiarly difficult. People both inside and outside the church look to it for help. The direction it gives is important. Its liturgy is a symbol of its understanding of faithfulness. If its liturgical practice demonstrates a recognition of the cries of the people and a commitment to struggle together, it signals faithfulness that is not static. Rather it points to a way of living characterized by hope, complemented by determination never to give up. When persons become members of the church they anticipate an experience of solidarity. They presume that within this collective relationship they will be invited to probe areas of meaning, to examine the relationship between faith and theology and to experience a relationship with God and others as modeled in the life of Jesus. The liturgy is the central experience that responds to these expectations.

The expression of such profound human needs is complex and difficult. Historically artists have been most successful in articulating human realities. They have been able to penetrate beyond superficial interpretations to the heart of human concerns. The contemporary church needs the help of artists to provide expressions of truth.

3

An Evolving Tradition: Listening to the Artists

The partnership between artist and church in the early centuries of Christianity, as we have seen in the case of Dura-Europos, was affected most significantly by the immediate needs of a new community: its formation, its development and its survival. The same alliance in the medieval period was influenced by the evolution of liturgical practice, the establishment of an international governing structure and the promulgation of its faith which spanned the intervening centuries. Saint-Denis was affected additionally by the confluence of political and ecclesial power in its leadership. The dominance of hierarchical decision-making, the mixture of royal/ecclesial purposes within the church and clearly developed aesthetic sensitivities contributed substantially to the relationship between artists and Saint-Denis. In both situations, artists provided important expressions of the theological, political, and sociological priorities of these Christian communities as well as reflections of the aesthetic values of the periods of history in which they lived.

Like the church of the past, the contemporary liturgical situation is affected profoundly by prevalent political systems, cultural values, and the church's theology, tradition, sociology, and history. But in sharp contrast to much of the past, the interaction between church and artists can no longer be taken for granted. Many artists have been alienated from contemporary churches; the church does not necessarily see art as

essential to its expression, while artists do not see a connection between the church's *raison d'être* and their work. Artists seek other places for employment.

This situation, influenced by economic and sociological factors as well as the diminishing quality of aesthetic education in the United States, affects many aspects of the church's choices. When art is not understood as a significant component of a church's expression of itself, the vitality of the church is weakened. Prosaic architectural designs are accepted in place of more imaginative structures. Vestments, vessels, and furniture are ordered without thought about the specific characteristics of a particular local context. Music is treated as a functional component of worship rather than as a rich resource for understanding and transformation. Visual art is considered as decorative rather than an integral part of the liturgical experience. Processions are viewed as utilitarian (they get people in place) rather than as invitations to experience the expressiveness of body language. Dance, drama, and poetry, if used at all, are reserved for special occasions instead of becoming a regular consideration in the planning of worship. The terms for a new partnership between artists and churches are long overdue.

Given the wide spectrum of needs the arts have served historically, the current situation is a challenge to both artists and churches. In order to consider new options, it is imperative for both parties to evaluate the potential of a working arrangement. Of what particular value will the various forms of art be to the church of the twentieth and twenty-first centuries? This chapter will discuss some responses to this question. The approach will be through the words of artists themselves.[1] In most instances, their reflections are concerned with art in general. After hearing them in these broad terms, I

[1]While I think Samuel Laeuchli makes an important point when he suggests that artists are not always the best persons to talk about their work, the statements of the artists cited in this chapter are critical for the church to hear if a partnership is to be valuable for both. See Samuel Laeuchli, *Religion and Art in Conflict* (Philadelphia: Fortress Press, 1980), p. 41.

will draw connections in the fourth and fifth chapters between their work and the worship life of the church.

Before listening to artists themselves, one word of caution is in order. Art communicates best when the participant interacts with it, rather than simply analyzes it. In a modest guide written to invite visitors to appreciate the extraordinary pilgrimage chapel in Ronchamp, France, Abbé Réné Bolle-Reddat reminds them not to draw conclusions quickly about the chapel's symbolism, but rather to take time to experience the church from different vantage points, during different seasons and times of day, so that they can perceive more fully this multidimensional phenomenon which defies categorical interpretation. Most artists would appreciate a similar resistance to making quick judgments about their work. A reluctance to draw easy conclusions about what they say about art as well opens up a broader spectrum for experience and evaluation.

What Art Offers

In order to understand how and why a partnership between church and artist would be valuable, it is important to investigate in a limited way what art can do. This exploration, through artists' own reflections on the subject, leads to a variety of answers. The selection here does not imply an exhaustive treatment; rather it is intended primarily to substantiate the concern of this book, and to be an invitation to readers to discover more for themselves. It has been influenced by the criterion of those aspects of art appropriately suited to worship, those which make a connection between divine and human reality. The selection includes particularity, meaning, revelation, illusion, emotion, awareness/conversion, memory, and values.

1. PARTICULARITY

In a provocative essay, "Innovation and Redemption: What Literature Means," the novelist Cynthia Ozick describes the purpose of literature:

to reject the blur of the "universal";
to distinguish one life from another;
to illuminate diversity;
to light up the least grain of being, to show how it is concretely individual, particularized from any other;
to tell, in all the marvel of its singularity, the separate holiness of the least grain.[2]

Every person has a story. That story is strongly influenced by gender, race, religion, and class. The distinctiveness of the mixture constitutes the particularity of each person and thus the uniqueness of his or her story. This particularity is invaluable both for itself and for the lens it provides to understand the concerns of our world. The creative route is from particularity to universality, not the other way around. Elie Wiesel, winner of the 1986 Nobel Peace Prize offers some telling examples:

By struggling on behalf of Russian, Arab or Polish Jews, I fight for human rights everywhere. By calling for peace in the Middle East, I take a stand against every aggression, every war. By protesting the fanatical exhortations to 'holy wars' against my people, I protest against the stifling of freedom in Prague. By striving to keep alive the memory of the holocaust, I denounce the massacres in Biafra and the nuclear menace. Only by drawing on his [sic] unique Jewish experience can the Jew help others. A Jew fulfills his role as man [sic] only from inside his Jewishness.

That is why, in my writings, the Jewish theme predominates. It helps me approach and probe the theme of man [sic].[3]

For too long, human beings have been lumped together as if their particularity were insignificant or at least unimportant to the world at large. Male terminology was acceptable in

[2]Cynthia Ozick, *Art and Ardor* (New York: Alfred A. Knopf, 1983), p. 248.

[3]Elie Wiesel, *One Generation After* (New York: Random House, 1970), p. 173.

describing women, as if women's identity was only important in relation to the development of men. Black people were recognized for the labor they provided for whites. Their culture and experience were considered insignificant. Native Americans were even more invisible. Their complex rich history is still told primarily through conflicts with whites over their land. Historically, particularity has defined peoples' societal boundaries. Unless one was a member of the dominant race, gender, and religion, the categorization was a liability. Wiesel and Ozick are among those artists who recognize the importance of particularity, not as an oppressive structure but rather a liberating one.

As a Jewish woman of this century, Ozick knows concretely the extremes of particularity. In her own lifetime, fanatic hostility over the difference of race threatened to eliminate an entire civilization. The pain and desperation of that time is an essential part of the Jewish story. It has shaped the values and dreams of succeeding generations. It plays an important role in continuing to shape Jewish identity and also in understanding other oppressive situations. Ozick suggests this explanation when she refers to her work as witnessing to the value of civilization against the desolation and pain of wilderness.[4]

But artists especially value particularity because it is a primary resource for interpreting human situations. Athol Fugard, a playwright from South Africa, refers to this concern in his reflection about the process of writing: "One of the ways I can prepare myself is to try to understand where I am and what I am about as a person now."[5] His particularity is the beginning of a process that extends from his own life to a presentation and interpretation of social situations which influence contemporary society. "I think it is almost impossible to have a piece of meaningful literature that does not

[4]Phrase used by Cynthia Ozick in a televised interview with Bill Moyers on PBS.

[5]Athol Fugard, in an account of a discussion of four playwrights entitled "Why Write for the Theatre?: A Roundtable Report," *New York Times,* February 9, 1986, p. 30.

involve some form of social criticism."[6] Fugard writes specifically about the confrontation between blacks and whites in South Africa. He shocks us into some faint understanding of what the daily persistent humiliation of apartheid can do to the human spirit.

Many other artists address the social evils of our world through some form of particularity. Arthur Miller speaks about the destructive price of class standards in the American system. Andy Warhol selected for his paintings the illusive results of success. Pablo Casals expressed resistance to the fascist dictatorship in Spain through music. Judy Chicago, in collaboration with many other women, sculpted, wove, and painted expressions not only of women's oppression but also of their potential. These artists begin with a particular perspective. Exposing this particularity becomes the catalyst for understanding the more universal dimensions of similar human situations.

In addition to the content of art, each artist's style also reflects the value of particularity. While artists are classified together under convenient categories, a close examination reveals distinctive characteristics that establish a particular contribution. Though it is by way of the music of Debussy or the pictures of Monet that one understands Impressionism, it is not at the expense of denying the differentiating characteristics each artist brings to that period. To lump together any group of artists is to miss the distinctiveness of their vision and to deny oneself the possibility of discovering personal connections with their work. In these connections one finds the beginning of their significance and meaning.

2. MEANING

Meaning in a civilized society is learned. It is absorbed through tradition and environment, reinforced through realized dreams and human crises, clarified with the passage of time. It is imbedded in the "essence" of human experience. What is this "essence?" Art offers some clues. Aaron Copland

[6]*Ibid.*

speaks specifically: "The art of music . . . [is] a haven wherein one makes contact with the essence of human experience."[7] Copland uses his own process as an example:

> What, after all, do I put down when I put down notes? I put down a reflection of emotional states: feelings, perceptions, imaginings, intuitions. An emotional state, as I use the term, is compounded of everything we are: our background, our environment, our convictions. Art particularizes and makes actual these fluent emotional states. Because it particularizes and because it makes actual, it gives meaning to *la condition humaine.*[8]

Copland understands the power of art to probe an evasive reality. He suggests that music provides moments where we can connect what we know about ourselves with something beyond what we know, and see in this interaction something of the meaning of human experience. His explanation helps to illumine the work of other artists. Elie Wiesel uses stories to unveil the evil of human powerlessness and of excessive human power. Emily Dickinson wrote poems to describe the pain "so utter that it swallows being." Mozart composed music to describe a world that has moved through despair and beyond it. With similar tools, Beethoven expressed a joy that knows no bounds despite all threats. Through choreography, Martha Graham makes concrete what power looks like. Henri Matisse illustrates the reality of resurrected life in design and architecture. In each case, the artist arrests human experience and puts it into a tangible form long enough for us to glimpse it.

Copland comments, "Each new and significant work of art is a unique formulation of experience; an experience that would be utterly lost if it were not captured and set down by the artist."[9] Copland does not imply that he or any other

[7] Aaron Copland, *Copland on Music* (New York: W.W. Norton, 1963), p. 51. Originally published by Doubleday, 1944.

[8] Aaron Copland, *Music and Imagination* (Cambridge: Harvard University Press, 1952), p. 111.

[9] *Ibid.,* p. 41.

artist sets out to sculpt or shape a particular human ex-
perience. Rather it emerges as the product of the creative
process, the interaction between the artist and the material.
Artists bring to the process their particular perspectives and
experience, the context in which they work, their discipline
and talents. The material offers a spectrum of shapes, shad-
ows, and sounds. The process is a series of responses. It
begins and ends in discovery. The concreteness of the work
unmasks what is elusive. At times the process provides self-
discovery. At other times (or perhaps in addition) it reveals
patterns of human and divine experience. Louise Nevelson,
writing from the perspective of a sculptor, sees it this way:
"The joy of creation is that it opens life to you as we under-
stand it. It opens and you become more aware and more
aware and that is the wonder of it."[10]

3. REVELATION

The life that art opens to us is a deepening and broadening
of our understanding, an experience of "what is yet not
known, thought, seen, touched."[11] In these words, Eva Hesse,
sculptor, is not referring to factual knowledge, though some
of that may be transmitted through art. Rather she is con-
cerned with ideas and feelings identified through interaction
with art. Her own work, characterized by "repetition, spon-
taneity, chance and contradiction" invites connections be-
tween shapes and textures and lived experience.[12] In the
connection is the revelation: something never before realized
becomes clear. It may be a perspective on the tedium and
liberation inherent in repetition. It may be a clue to the effects
of risk. It may be an affirmation of contradiction as a sign of
integrity. It may be a moment of pure joy or satisfaction that
has no accompanying verbal explanation. Whatever the inter-

[10]Louise Nevelson, "Nevelson Maquettes for Monumental Sculpture,"
Pace Gallery Catalogue, May 2-27 June, 1980.

[11]Susan Keyes, reporting on Eva Hesse, *Newsletter of The National
Museum of Women in the Arts,* Washington, D.C., Spring, 1985.

[12]*Ibid.*

pretation, art has become a vehicle of insight.

John Berger, art educator, is convinced that the revelation available in art is missed often because many people cannot make the connections between art and human experience. His book, *Ways of Seeing,* is an effort to help people learn how to forge these relationships. Seeing is the first step. After all, he reminds us, it is the first expression of a relationship. "Seeing comes before words. The child looks and recognizes before it can speak."[13] Before she can speak, the child draws conclusions, establishes an identity, makes choices, affirms relationships. Obviously, verbal discourse is not the only or often the most adequate way of knowing or of expressing oneself. Art offers an alternative and an additional possibility to both artist and participant. In fact, Berger argues that such interactions can confer power. Speaking specifically of the use of visual images, he states "Within [a new language of images] we could begin to define our experiences more precisely in areas where words are inadequate. Not only personal experience, but also the essential historical experience of our relation to the past: ... the experience of seeking to give meaning to our lives, of trying to understand the history of which we can become the active agents."[14] Berger insists that opening up the potential of "seeing" provides revelations about ourselves and our past that affect our present and future choices and actions.

The process of revelation through art involves more than seeing. It requires a temporary surrender to someone else's experience, the experience which the artist has shaped. In that surrendering, Northrup Frye suggests, we come to know something not only about the artists but also about ourselves. He describes the revelatory process:

> You wouldn't go to Macbeth to learn about the history of Scotland—you go to it to learn what a man feels like after he's gained a kingdom and lost his soul. When you meet a character such as Micawber in Dickens, you don't feel that

[13]John Berger, *Ways of Seeing* (New York: Penguin Books, 1972), p. 7.
[14]*Ibid.,* p. 33.

there must have been a man Dickens knew who was exactly like this: you feel like there's a bit of Micawber in almost everybody you know, including yourself. Our impressions of human life are picked up one by one, and remain for most of us loose and disorganized. But we constantly find things in literature that suddenly coordinate and bring into focus a great many such impressions.[15]

Art can reveal what we are groping to understand, what we know deep within us but are unable to express. The power of revelation is one of art's distinctive features.

4. ILLUSION

Not in facts, says Frye, but in the nuances that surround them, is the connection discovered between literature and human experience. What art reveals is not immediately obvious. Louise Nevelson explains why. "The work that I do is not the matter and it isn't the color, form, wood as such. It adds up to the in-between place, between the material I use and the manifestation afterwards.... The place of in-between means that all of this that I use ... is something I'm using to say something else ... something beyond [painting or sculpture] that we make."[16] Nevelson and Frye are referring to the quality of illusion, that characteristic of art which reaches beyond the boundaries of tangible realities.

The purpose of art is not the imitation of reality. Rather, art is created to express "otherness" or illusion. It is the "bearer of an idea."[17] In a lengthy and rich discussion of illusion in art, Susanne Langer insists that illusion or "semblance" is the attribute that qualifies a work to be called art. Illusion, Langer maintains, differentiates art from reality, by placing it in the realm of the symbolic where an object or a sound commu-

[15]Northrup Frye, *The Educated Imagination* (Bloomington: Indiana University Press, 1964), pp. 63-64.

[16]*Dawns & Dusks: Louise Nevelson,* taped conversations with Diana MacKown (New York: Charles Scribner's Sons, 1976), pp. 123, 125.

[17]Susanne Langer, *Feeling and Form,* pp. 45-47.

nicates an understanding of reality without actually being real. However, illusion does not remove from art its connection with reality. "The form is immediately given to perception, and yet it reaches beyond itself; it is semblance, but seems to be charged with reality."[18] Sound, shapes, words, texture, movement arranged into artistic forms invite participants into a world of knowing where literal interpretation is replaced by the logic of symbols and where immediate recognition is replaced by an exploration of layers of meaning. "This is what we are trying to accomplish:" says the dancer Isadora Duncan, "to blend together a poem, a melody and a dance, so that you will not listen to the music, see the dance or hear the poem, but will live in the scene and the thought that all are expressing."[19]

The task of the artist is to create forms that express feeling, passion, emotion—those intangible aspects of human experience that are a part of each individual's life. The work is difficult and demanding. It requires artists to experiment, to risk both success and failure, and to be constantly sensitive to their own insights and the evolving needs of human beings. The task is sometimes overwhelming. Käthe Kollwitz writes, "I can scarcely think that I have been so able to communicate myself or—more than that—to have been the direct mediator between people and something they are not conscious of, something transcendent, primal."[20]

The illusion of art pushes us to probe deep within ourselves, wrestling with its expressiveness to discover what it means. Its meaning can be difficult to grasp because what it expresses is not so much a feeling as ideas about feelings.[21] Two steps removed from what is obvious demands twice as much interaction.

[18]*Ibid.,* p. 52. Langer devotes an entire chapter to the subject of "semblance," providing detailed exploration of this term, pp. 45-68.

[19]Isadora Duncan, *Isadora Speaks,* edited and introduced by Franklin Rosemont (San Francisco: City Light Books, 1981), p. 50.

[20]Martha Kearns, *Käthe Kollwitz: Woman and Artist* (Old Westbury, NY: The Feminist Press, 1976), p. 148.

[21] Langer, *Feeling and Form,* p. 82.

5. EMOTION

Emotion according to Langer is "the thought in the work ... the non-discursive concept of feeling."[22]

Why must I create? Aaron Copland asks. Because composing music meets "the basic need to make evident one's deepest feelings about life."[23] Most human beings share this need. Art offers forms to meet it.

The expression of emotion is the driving momentum for the creative process in which artists are engaged. Artists are compelled to give emotion shape and substance, to create a form in which feelings can be perceived. "I believe one thing," said Martha Graham, "that today is yesterday and tomorrow is today and you can't stop."[24] Artists respect the breadth as well as the internal propulsion of emotion. They understand that every mark on a canvas, every note of a composition, every choice of a material contributes to or takes away from its statement. "The whole arrangement of my picture is expressive," says Henri Matisse. "The place occupied by the figures or objects, the empty spaces around them, the proportions—everything plays a part...."[25]

From painter to musician, dancer and architect, artists evaluate an artistic work on its ability to convey emotion. Its expression is a distinguishing feature of art. For Eileen Gray, architect, the contemporary influence of simplification as the primary guiding factor for the shape and textures of modern architecture limits the expression of emotion. "What is needed is the rediscovery of the human well below the material surface and the pathos of this modern life which up to now has been interpreted only through a sort of algebraic language of forms."[26] She believes that in the effort to return to simpler

[22]*Ibid.*

[23]Copland, *Music and Imagination,* p. 41.

[24]Martha Graham in "Artists in Old Age: The Fires of Creativity Burn Undiminished" by Nan Robertson, *New York Times,* January 22, 1986.

[25]Henri Matisse in Langer, *Feeling and Form,* p. 83.

[26]Deborah F. Nevins, "An Interview of Eileen Gray" in *Making Room: Women and Architecture, Heresies,* Vol. 3, No. 3 (1981), p. 71. *Heresies: A Feminist Publication on Art and Politics,* published by Heresies Collective, Inc., 225 Lafayette Street, New York, NY, 10012.

forms, the connection between architecture and human life has been lost. For Gray, expressions of emotion, spirituality, and symbolism are inherent in art. Therefore, Gray demands that architects be more responsible not only for the use of the latest scientific information in constructing buildings, but also for expressing the "soul" of human life.

Copland, Graham, Matisse, and Gray—representing four different forms of art—all affirm the centrality of emotion in art. It is the fulcrum around which shapes, sounds, movements are organized. The subject matter is second to the expression of emotion. Matisse comments:

> A work of art must carry in itself its complete significance and impose it upon the beholder even before he [sic] can identify the subject matter. When I see the Giotto frescoes at Padua I do not trouble to recognize which scene of the life of Christ I have before me, but I perceive instantly the sentiment which radiates from it and which is instinct in the composition in every line and color. The title will only serve to confirm my impression.[27]

To understand the purpose of art, to create it and to respond fully to an artistic experience, it is imperative to push beyond what may be obvious at first to those deeper layers where meaning is discovered and rediscovered, where the emotion or "thought" in the work is revealed. In this process the value of an artistic experience is located and absorbed, providing the context for an experience of transformation.

6. AWARENESS/CONVERSION

The ultimate goal of art is to move the person engaged with it to make a connection between the artistic creation and human experience. Chagall talks about his painting as "a tissue of flesh, made up of all my thoughts, dreams and experiences.... A picture stands alone, and its motifs have

[27]Langer, *Feeling and Form,* p. 83.

to ask questions, and provide answers as well."[28] Art invites people into a spectrum of movement. In any one situation there can be numerous responses. What artists hope is that the engagement will stimulate awareness and perhaps challenge our perspectives.

There is evidence from many quarters. Georgia O'Keeffe paints big pictures so that people will feel compelled to stop and take notice. Louise Nevelson reminds us that art is everywhere. It takes a creative person to see it.[29] Aaron Copland writes that "a masterwork awakens in us reactions of a spiritual order that are ... waiting to be aroused."[30] Charles Morgan points to drama as an experience that can provide "a vision, a sense of translation and ecstasy, alien to his common knowledge of himself."[31] C.E. Montague observes: "At the climax of a tragedy it seems as if the average man or woman could understand almost anything—even things which may again become incomprehensible to them the next day when they try to understand how they understood them."[32]

Awareness is a characteristic of both artists and participants in art. Art unearths, stirs, shakes up, keeps alive aspects of human experience that otherwise plunge into oblivion or, at best, occupy a back burner. Through its capacity to emphasize, to focus, and to divert distracting ideas at least temporarily, its impact burrows into aspects of our consciousness, often before we know it. Art asks a question. The response can be rejection, indifference or involvement. In the latter case, it encompasses a threefold process: an awareness of the question, a willingness to hear it, and movement toward

[28]*Chagall's World. Reflections from the Mediterranean.* Conversations with André Verdet. Portrait Photographs by Bill Wyman. (Garden City, NY: The Dial Press, Doubleday & Co., Inc., 1984), p. 36.

[29]Nevelson, *Dawns & Dusks,* p. 81.

[30]Copland, *Music and Imagination,* p. 17.

[31]Charles Morgan, "The Nature of Dramatic Illusion" in *Essays by Divers Hands* (a volume of *Transactions* of the Royal Society of Literature in England), N.S., Vol. 12, ed. R.W. Macon, 1933, p. 64.

[32]C.E. Montague, *A Writer's Notes on His Trade* (Garden City, NY: Doubleday, Doran and Co., 1930), p. 237.

change. Charles Morgan describes it this way: "The order of his [sic] experience is always the same—a shock, and after the shock an inward stillness, and from that stillness an influence emerging, which transmutes him. This great impact is neither a persuasion of the intellect nor a beguiling of the senses. . . . It is the enveloping movement of the whole drama upon the soul. . . . We surrender and we are changed."[33]

While every experience of art does not end in obvious conversion, it is the intention of every artist to enlarge the parameters of our consciousness through an encounter with a work of art. Isadora Duncan comments, "A dancer, if she is great, can give to the people something that they will carry with them forever. They can never forget it, and it has changed them, though they may not know it."[34]

The artist provides questions. Shaped from the "tissue of the flesh" the questions are influenced by an historical context and personal perspectives. Answers are similarly affected by time, space, and experience. However, the awareness and conversion that can result from this dialogue extend beyond these limitations.

7. MEMORY

The essence of important events is often kept alive through art. Tragic occasions, experiences of unadulterated joy and many other experiences along the spectrum of human life are moments that beg to be remembered permanently. Art offers unparalleled possibilities for recalling the meaning of significant events.

Marc Chagall says "My paintings really are my memory."[35] He is referring here specifically to the agony of the Holocaust, the same reality which moved Elie Wiesel to write novels, Etty Hillesum to keep a diary, Nelly Sachs to create poems, and Darius Milhaud to compose music. The facts of any tragedy cannot communicate the depths of the pain, the

[33]Morgan, p. 64.
[34]Duncan, p. 52.
[35]*Chagall's World*, p. 36.

suffering, and, in this case, the evil of an event. The characteristics of art mentioned above make it possible for artists to provide a more adequate expression of the spirit that permeates and underlies it. As tragic individual and world situations continue, from the ravaging spread of fatal disease and insidious persecution to the genocide of another people, artists continue to express this reality for our understanding and for our remembering.

Not only the memory of tragedy, but also the expression of beauty's essence is the province of the artist. Copland uses the music of Palestrina as an example: "... At [their] best Palestrina's masses and motets create an ethereal loveliness that only the world of tones can embody."[36] The techniques and talents of artists provide them with unique capabilities to see, hear, create and recreate expressions of beauty. The photographs of Ansel Adams, the furniture designs of the Shaker community, the poetry of Edna St. Vincent Millay, record visions of beauty that enable others both to reconstruct their own experiences as well as to discover new ones.

In remembering tragedy and beauty, human beings are changed. The artist provides the nuances that "scream louder than the thing that's obvious,"[37] warning us against the repetition of tragedy and summoning us into a recapitulation of beauty.

8. VALUES

Not only do the arts stimulate memory but they also reflect and communicate values. "Great art never ignores human values," says Martha Graham, "therein lies its roots."[38] Contemporary thoughts and situations influence the content, meaning, and form of the arts. The interplay between art and ideas mirrors, interprets, and clarifies values whether they be

[36]Copland, *On Music,* p. 42.

[37]Nevelson, *Dawns & Dusks,* p. 28.

[38]Merle Armitage, *Martha Graham,* p. 84. Originally published by author in 1937, republished by Dance Horizons, Inc., Brooklyn, NY, 1968, second printing.

political, personal, aesthetic, or universal.

Nadine Gordimer, novelist and short story writer, provides an example. She explains that while the newspapers can provide facts, "it's the playwright, the novelist, the poet, the short-story writer who gives you some idea of why."[39] The "why" reveals underlying values. Gordimer's work primarily, but not exclusively, uncovers and comments on political values. Well known as a writer whose subject matter reflects the conflicts in South Africa, she poignantly writes about everyday situations that expose the "whys" of the apartheid system. Through an exposition of these experiences, with which many can identify, she unmasks those values that legitimate the oppression of an entire race. Gordimer's work is so convincing that the government has banned some of her books to try to lessen their impact.

Poems of Adrienne Rich, June Jordan, Walt Whitman, and Pablo Neruda, the plays of Marsha Norman, the cartoons of Gary Trudeau, the music of many contemporary rock groups, all find their material in sensitivity to the struggles for power, prestige, and position that proclaim the political values of this century. June Jordan distinguishes such poets as New World artists. They produce poetry that is "as personal, as public, as irresistible, as quick, as necessary, as unprecedented, as representative, as exalted, as speakably commonplace, and as musical, as an emergency phone call."[40] The work of all these artists is wrenching, confrontative, and perceptive, offering opportunity to call by name the subtle forces that drive human decision-making and activity.

Personal values are also highlighted in the arts. Artists reflect their own values and inevitably touch similar universal concerns. Two examples are contemporary playwright Tom Stoppard and painter Henri Matisse.

Stoppard reflects his concern about immortality. In *Travesties* he speaks through James Joyce, a character who plays the familiar literary figure. Joyce and Tristan Tzara are dis-

[39]Michiko Kakutani, "Gordimer on Art and Apartheid," *New York Times,* January 14, 1986, p. C-12.

[40]June Jordan, *Passion* (Boston: Beacon Press, 1980), p. xi.

cussing the phenomenon of Dadaism when Joyce breaks into the conversation with a definition of an artist: "An artist is the magician put among men [sic] to gratify—capriciously— their urge for immortality."[41] Joyce illustrates. "What now of the Trojan War if it had been passed over by the artist's touch? Dust. . . . And yet I with my Dublin Odyssey will double that immortality, yes by God *there's* a corpse that will dance for some time yet and leave the world precisely as it finds it."[42] How important to us all is that quest for immortality, disguised in many forms!

Henri Matisse speaks about his search for truth. He comments about the design and decoration of his chapel in Vence. "I regard it, despite all its imperfections, as my masterpiece . . . as an effort which is the culmination of a whole life dedicated to the search for truth."[43] These words of Matisse reveal a powerful force that drove him to continue expressing what he saw and felt. They indicate also a sense of satisfaction that in this work he had achieved a goal developing in him throughout his artistic life.

The expression of political and personal values is strongly affected by aesthetic values. Roger Sessions speaks specifically of the example of music: "The composer is no longer simply a craftsman; he [sic] has become a musical thinker, a creator of values—values which are primarily aesthetic, hence psychological, but hence, as an inevitable consequence, ultimately of the deepest human importance."[44] Sessions is pointing to shapes, materials, sounds, colors and textures themselves as expressive of human understanding and development. The expression of risk in the sounds and silences of John Cage, of limitlessness in the sculpture of Louise Nevelson, of courage in the pilgrimage chapel at Ronchamp by Le Corbusier, of freedom in the colors of Van Gogh are some of many ex-

[41]Tom Stoppard, *Travesties* (New York: Grove Press, Inc., 1975), p. 62.

[42]*Ibid* (italics Stoppard).

[43]These reflections and others on the Chapel of the Rosary are found in a pamphlet sold at the chapel entitled "Vence Chapel of the Rosary planned and carried out by H. Matisse."

[44]Coplan, *Music and Imagination,* p. 44.

amples expressing personal values through aesthetic constructs.

The bond between aesthetic values and everyday life is reflected not only in the materials and the organization of artistic work but also in the evolution of its form. As Martha Graham says: "The old forms could not give voice to the more fully awakened man [sic]. They had to undergo metamorphosis ... in some cases destruction, to serve as a medium for a time differently organized."[45] Aesthetic values reflect and sometimes even predict the priorities of history. Their rationale for change is not independent of contemporary human conditions. As a result, art offers a distinctive medium for the interpretation and understanding of many aspects of conscious and unconscious human experience.

Art's success rests primarily on its ability to touch people in specific and enduring ways. Art that has true meaning connects with primary human experiences: loneliness, love, despair, hope, joy, freedom. It invites rather than coerces, offering a perspective that requires interaction but does not prescribe its terms nor determine its conclusion. This aesthetic process is similar to the divine/human relationship: confrontation, reflection, response. In its liturgy the church also hopes to embody this process. Its success depends on its ability to connect to people's immediate and long term needs.

It is not uncommon for some people to express dissatisfaction with the church because its liturgy seems so disembodied, so removed from the everyday critical concerns of its members. Some worship services can be described as sterile, aloof, distant, implying that they convey a spirituality that concentrates on the "needs of the soul" rather than the total reality of a human being. They proceed as if the particular characteristics or concerns of the community do not matter, as if the power of the rite transcends any expression of immediacy or connection with the memories or values of the community, as if meaning can be understood without stating its relationship to a concrete context. Or, put another way, these services can emphasize the life of the historical Jesus and of the saints that have imitated him most closely in such a

[45]Armitage, p. 85.

way that any connection between them and the current worshiping community is not only unimaginable but in some cases irresponsible. Anne E. Patrick reflects on the latter situation with a clear example. She comments on the recent beatification of the nun Marie Clementine Anwarite, who according to the account that accompanied the story of her beatification, was an example of the "primordial value accorded to virginity."[46] Her virginity was protected because she chose to be killed rather than accede to the violent crime of rape. Patrick uses this story as a framework for discussing developing attitudes about the definition of virtues and values. It is cited here to suggest that the materials the church often chooses to provide examples for our lives no longer work effectively for many churchgoers. Women fight for their integrity; they will not surrender their lives for some abstract concept of virtue. Women as well as all other humans need narratives, experiences, participatory expressions that address issues which emerge from the demands of this time in history.

The changes in the themes and materials of artists during this century reflect the changes inherent in our current historical situation. Artists have a unique capacity to anticipate and express the deepest concerns of human beings. The churches can use artists' insights in order to meet more effectively their goal of providing liturgical expressions that connect the reality of God with the concrete realities of human beings. Such a partnership can be a rich exchange that benefits both artist and church, and it is to an illustration of its potential that we now turn.

[46]Cited in Anne E. Patrick, "Narrative and The Social Dynamics of Virtue," *Changing Values and Virtues,* Concilium 191(1987), ed. Dietman Mieth and Jacques Pohier, p. 74.

4

The Future Tradition

I'm coming to believe that all of us are ghosts.... It's not just what we inherit from our mothers and fathers. It's also the shadows of dead ideas and opinions and convictions. They're no longer alive, but they grip us all the same, and hold on to us against our will. All I have to do is open a newspaper to see ghosts hovering between the lines. They are haunting the whole country, those stubborn phantoms— so many of them, so thick, they're like an impenetrable dark mist. And here we are, all of us so abjectly terrified of the light. (Henrik Ibsen, *Ghosts*)

The material in this chapter focuses on the future liturgical tradition we are called upon to create. Like all else in this book, it is concerned primarily with connection, the connection between what human beings feel and need, and what they actually experience in the churches on Sunday. One way of making this connection, as we discovered, is through a partnership with artists whose gift it is to express what is intangible, whether it is a quality of compassion, a feeling of ambivalence, a stirring of commitment, a sense of aloneness or of community, the exhaustion of anxiety, the freedom of love.

This investigation will bring together the characteristics of the contemporary church and its liturgical needs that we examined in Chapter Two and relate them to the qualities the arts offer, as evinced in Chapter Three. The intention is to discover what it is that the church should fulfill through its worship.

This chapter will deal with specific examples rather than theories, *offered not for imitation but for illustration.* They are drawn from work done at Union Theological Seminary, an interdenominational community of faculty, staff, and students that meets four times a week for worship. They represent efforts to uncover forms and symbols that meet the needs of a community that treasures its multicultural character, that takes seriously concerns of liberation, and that understands its responsibility to engage evolving theological, biblical, historical and sociological interpretations in its worship.

While local parishes may have less immediate need to be involved with the cutting edges of theological inquiry, the learnings from these examples connect to many different situations. They raise significant questions about forms and symbols too often taken for granted. They offer tested suggestions to stimulate ideas in one's own situation. They challenge communities to examine the needs and concerns of a specific congregation in order to evaluate the relationship between the ritual components of their worship and the lives of the people who participate in it. While it is clear that every situation has its own particular requirements (Union Seminary is no exception), theological communities and local parishes share similar aspirations or goals, i.e., to make evident the connection between their lives and a belief in divine reality and to worship in such a way that it is a paradigm for daily choices.[1]

[1]These examples derive from my work with the community of Union Theological Seminary in the City of New York where students, staff, and faculty collaborate in planning worship. While the primary role of the services is a context for the prayer and praise of this community, they are also planned as examples for our work in parishes.

James Chapel, renovated by architect Philip Ives in 1979, both inspires and accommodates this liturgical work.

Stretching Toward the Future[2]

Several years ago members of the Union Seminary community collaborated to offer a worship service that expressed the history of worship at Union. The service was divided into three parts. The past was easily reconstructed through recollections of faculty members and available films. The present was easily shaped by examining liturgies from the preceding year and extracting engaging components. The future was not so readily conceived.

The concern with which we wrestled was not about a form for the future. That did not seem important. Rather, our goal was to provide an experience that would help us prepare for future expressions of worship that differed from what we had always known.

The elements we selected to initiate our understanding of "newness" were these: a familiar scriptural text which incorporates a fantasy; electronic music, a phenomenon whose possibilities have only begun to be explored in the church; and dance, choreographed so as to see beyond the physical confines of the chapel space. There were other ritual elements, too, of course, but these three bore the burden of suggesting the future.

Scripture: We chose verses from the Book of Revelation 21:22–22:5 as a focus.

> I came to the city in search of the temple; but there was no temple, no temple in the city: and, although there was light, radiant light, neither sun nor moon shone upon it. I asked them in the city, "Where is your temple, where is your sunlight?" And they said, "Seek not for stone and mortar, our temple is the Lord. We have no need of sunlight, no need for the moon; our light is the glory, the glory of the Lord. And the gates shall never close by day; And there shall be no nighttime there!" Alleluia.

In this section, the author describes a vision of the New Jerusalem, a city in which there is no temple, where there is

[2]The complete order of worship for this service and all subsequent cited ones discussed in detail, can be found in the appendix of this book.

no need of sun or moon to shine, a city where the presence of God is everything. We were aware that the future liturgical tradition in our churches will continue to be as hampered as it has been historically by a limited vision, both institutional and personal. It will also continue to be confined by the immediacy of specific local needs. However, we believed in the power of liturgy to point beyond humanly circumscribed boundaries. To dip into that power was our intention. These verses of scripture offered a welcome opportunity.

Music: This scripture reading was preceded by music composed on a computer (Charles Dodge's "Changes") whose unanticipated sounds alerted the community to something different. Immediately following the reading, the community participated in an embodiment of the text through Calvin Hampton's "Our Temple is the Lord," a piece commissioned for this occasion. Composed on a synthesizer for electronic tape, this piece featured a soprano soloist.

The sounds produced by a synthesizer were unfamiliar but melodious. The community was challenged to listen keenly in order to catch its meaning. The soprano line, quite independent of the instrumental accompaniment, was expressive of the remarkable qualities of the text.

Dance: Through choreography based on the music and the text, the space of the chapel was sculpted by a dancer inviting the community to see shapes and textures, some of which had been there as long as the chapel had been, and others formed and unformed by her movements that were new to us.

The result was an extraordinary experience of excitement, ambiguity, anticipation, mystery, participation, along with some disorientation for those who like their liturgy predictable.

Community prayer, comments, singing, a meal and a blessing followed in the service.

Our search at Union to envision a liturgical future through an actual ritual included a partnership with artists. The process began with an assessment of the community's needs combined with an invitation to artists to be part of the experience. It was clear that a simple reading of the text would not be sufficient to express its breadth of vision and meaning. More than the sound of words was required. Music and movement

in conjunction with the text did satisfy that need. It engaged not only our minds but our bodies as well, providing the energy and texture to imagine and feel the meaning of this text and its implications for the present as well as the future.

The search for a temple in the city articulates well the future tradition of the church, not so much a temple with walls, though that is often the context of our quest, but a gathering of people who are looking.

The music and choreography of Hampton's "Our Temple is the Lord" were intended to stretch our capacity to see and hear and touch something beyond what we have been accustomed to anticipate. It was an invitation not only to see differently but also to discover what we want of the church, and perhaps to disclose also those corners where ghosts, so poignantly described by Ibsen, inhibit our freedom and God's activity among us. We needed composers and choreographers to fulfill these goals. We could not have done it alone.

What is worship likely to offer us in the future? Are we truly at a crossroads, a point where we must launch out on to uncharted paths in order to satisfy liturgically those human aspirations and longings which contemporary worship leave untouched? Can we salvage the old by making changes here and there?

Because these questions are critical for the development of liturgy I give below several examples of ways in which the worshiping community at Union Theological Seminary has "launched out" in an attempt to satisfy new longings for connection and meaning.

Advent: A New Look
at an Overly Sentimentalized Season

It is within the tradition of many churches to offer a program of "lessons and carols" during Advent in order to supplement Sunday services with a festive reminder of the meaning of the season and its anticipation of Christmas. While this practice is effective in some churches, it does not always provide enough variety to represent evolving theolog-

ical reflections on the significance of Advent, nor does the selection of readings and music include the many aspirations of people who gather. In some situations the traditional event merely reinforces the power of the dominant culture, promoting a white Jesus whose birth inspires songs of comfort and superficial piety. This portrayal of Advent is in stark contrast to the surprising and liberating aspects of the actual historical experience of Jesus who came among us under the most unexpected and disquieting conditions, a poor member of a despised race in a backwater of the Roman empire. As a theological community studying the meaning of the incarnation, members of the faculty and students at Union planned in 1983 a new look at Advent, called "The Revelation of God to Ordinary People."

The service began with an encounter: ordinary people, seen through slides and sounds of women from all countries, races, and economic levels alternating periodically with pictures of Mary and of Mary with Jesus. These pictures were shown on the front wall while flashes of color, abstract art, were projected on the side walls and on the front sections of the ceiling. This encounter with ordinary folks (through slides) continued throughout the service though at a much slower pace. The choice of women as subjects was a conscious one. It attempted to redress the historical neglect of women as strong, vital symbols of divine presence and activity. Simultaneously, it represented a constructive response to a situation where often the church is hesitant to initiate change because of the magnetic pull of tradition. (What Ibsen refers to as ghosts, some theologians call idols, i.e. the perpetuation of images or interpretation of concepts as if they were absolutely essential to the expression of the nature of God.)

A congregational hymn, "People of Faith," shows how new words written to a familiar tune can capture the spirit of the event:

> People of love cast doubt aside.
> Cling to hope, in peace abide.
> History sings of faithful living.
> God is still merciful, still is forgiving.

> Children of love, prepare the way,
> God will visit us today.[3]

Following the hymn came scripture selections, some ordinarily associated with Advent and others not often heard as part of the season. These were the stories of Hagar (Genesis 16:8-14) Shiphrah and Puah (Exodus 1:15-21), Hannah (I Samuel 1:9a, 19c, 2:1-11), Mary and Elizabeth, (Luke 1:26 and 39) and Mary (Luke 1:47-55). Each story was told by a person who, in dress and idiom, represented a contemporary interpretation of the text. The connection was clear without explanation. Then, works of artists expressed a response to the text. They included dance choreographed especially for the occasion, the reading of short excerpts of fiction, poems, and the performance of music taken from contemporary Broadway musicals, gospel music or hymnals. Each section concluded with a participatory prayer written by a member of the community. The diverse parts were unified not only by their connection to the season, but also by the same musical refrain, "Divinum Mysterium," hummed, whistled, played or sung at various intersections of the parts.

What led us to dare to present Advent in this somewhat unorthodox fashion?

Since the meaning of Advent often gets lost in the commercial enterprise of Christmas, we wanted to design a service which would offer an alternative experience, one that would express anticipation, anxiety, and hope inherent in this season of preparation. Words can only clumsily convey the experience of deep feelings which are characteristic of this season. But artists can communicate these feelings in any number of ways. The pain and anxiety of Hagar, for example, was represented poignantly through the haunting sounds of a saxophone and the angular, tortuous movements of a dancer. The extraordinary courage of Shiphrah and Puah, expressed in their determination to protect a human being despite repercussions for their own lives, was mirrored in the music of

[3]These words, adapted by Sharon Webb, a member of the Union community, offer an alternative to the text of "People Look East, the Time Is Near."

"Look Over There" from *La Cage aux Folles,* in which two gay men facing societal discrimination nevertheless reaffirmed their pledge of mutual commitment. The music said it better than words could have done.

The formality of traditional "lessons and carols" services often does not connect easily to the real experiences of ordinary people. We intended this service to make concrete contemporary applications of seasonal texts. For example, the story of Hagar, the first woman in the historical memory of Israel to bear a child,[4] was told in such a way that it would relate to the plight of many suffering people: "the faithful maid exploited, the black woman used by the male and abused by the female of the ruling class, the surrogate mother, the resident alien without legal recourse, . . . the pregnant young woman alone, the expelled wife, the divorced mother with child, . . . the self-effacing female whose own identity shrinks in service to others."[5] The contemporary church needs to hear the stories of many women, narratives that describe models of courage, collaboration, and compassion.Such characteristics were not only expressed in the innovative and imaginative situational response of Shiphrah and Puah but also in the stories of Mary and Elizabeth, each of whom was asked to play a role she did not anticipate.

One of the lessons of Advent is that power, wealth, and position are not characteristics aligned with the incarnation of Jesus in human life. The emphasis is rather on the beauty, integrity, and faithfulness of ordinary people with everyday concerns for mercy, strength, freedom, food and love. In the stories chosen, God is revealed through commonplace people with commonplace concerns. We hoped in the use of these stories to center our attention not solely on Jesus in the first century but on the revelation of God among us now.

Some conclusions were borne out by this service:

1. It is not enough to offer a familiar advent ritual each year. The church has a responsibility to look carefully at the

[4]See Phyllis Trible, *Texts of Terror: Literary-Feminist Readings of Biblical Narratives* (Philadelphia: Fortress Press, 1984), p. 29.

[5]Ibid., p. 28.

meaning of liturgical seasons and feasts in order to discern what their celebration can convey *at a particular time for a specific community*. This mandate does not imply a manipulation of texts, but rather an honoring of their potential which recognizes that new interpretations evolve through studying the texts in the contemporary contexts where we must hear them.

2. A mixture of the old and the new, as exemplified in music as ancient as "Divinum Mysterium" and as contemporary as "Look Over There" suggests both the continuity of tradition and the richness of unexpected sources of revelation.

3. The use of visual images to complement written texts enhances the possibilities of communication and connection, often elusive in symbolic writing.

Lent: A Fresh Encounter with a Familiar Text

Like the Advent season, the period of Lent reminds us of familiar themes and narratives. While the familiar can sometimes make us feel securely at home and at rest, repetition is notorious for dulling our awareness. A Lenten service planned at Union in 1981 shows how "Liberation from Bondage," a classic theme of Lent, can be reworked.[6]

Since liberation continues to be a central struggle for most of the world's people, the Exodus story (chapters 2-15) is often heard in worship. It is interpreted most effectively by those who have been imprisoned or discriminated against, whether by virtue of sex, race, class, religion, political choices or unaccepted social behavior. So the question becomes: how can the rest of us, members of churches who have enjoyed many privileges, experience our own bondage and the effects of the bondage we impose on others? Robert E. Seaver employed aspects of drama and literature to offer one possibility.

The service had a few simple components: opening organ music ("Prelude" by Isadore Freed), the reading of selected verses from Exodus interspersed with the Negro Spiritual,

[6]This service was planned by Robert E. Seaver, Professor Emeritus of Speech and Drama.

"I'm So Glad Troubles Don't Last Always," the reading of a psalm, the singing of a hymn, and prayer. New translations and a change of posture helped to provide a fresh hearing of this story.

Once the reading of the exodus passages was completed, the community was invited to stand and form a procession for the remainder of the service. As the people sang, "Guide me, O thou great Jehovah, pilgrim through this barren land ..." we walked and we walked and we walked, as people on the move together. We stopped only to listen to the verses of Psalm 130 (Out of the depths I cry unto thee, O Lord) and to pray in response corporately for mercy, personally in silence, and once again corporately for a specific need. The words of the psalm were not from a traditional translation but from the pen of a contemporary Jewish poet, David Rosenberg. A comparison of the texts demonstrates the power of his poetry to express feelings consonant with our present awareness as people who participate in perpetuating bondage.

Revised Standard Version	*Blues of the Sky* by David Rosenberg
Out of the depths I cry to thee, O Lord! Lord, hear my voice! Let thy ears be attentive to the voice of my supplications!	I am drowning deep in myself, Lord I'm crying I'm calling you hear this voice, Lord find me in your ears the mercy of your attention as it looks through the shell of my selfishness[7]

Rosenberg's words make immediate connections with the most personal and communal aspects of the significance of the exodus in our time. The poem expresses pain, longing, search for change. It continues:

[7]David Rosenberg, *Blues of the Sky* (New York: Harper & Row, 1976), p. 38.

but you allow us forgiveness
allow a song
coming through us

to you
as I call to you
as I rely on these words

Longing does not have to be an isolated experience. The
same power that delivered people from bondage, as recounted
in the Book of Exodus, enables us who are walking together
now to be in solidarity with each other in the struggle for
freedom. As we walked and listened and pondered what we
were hearing, we learned something of the persistence and
faith required in the struggle for liberation.

Some important lessons from this service:

1. Simple changes of posture and a fresh translation of a
familiar text can awaken the community to an insight about a
text, in this case, the Exodus story. There was a marked
difference between sitting and listening to the reading, or even
hearing an impassioned sermon about it, and having to get
up, listen and move together as a community. The poetic text
invited us to feel our own particular exodus: "I am drowning
deep in myself. . . ." But awareness did not stop on this
personal level. It acknowledged a need for collaboration,
"allow a song coming through *us* to you" (emphasis mine).
The tension between personal and social responsibility was
embodied in individual listening and in corporate movement
from place to place around the chapel. Nothing was said
about how to move (everyone did that quite differently). The
invitation was to walk in concert with others, reflecting on
our own lives and also on the corporate responsibilities in-
herent in accepting membership in a church.

2. The seminary community, like almost every parish com-
munity, does not like to move. The invitation to get up and
walk was a surprise and perhaps a source of some temporary
anxiety. Participation in processions, gestures or dance is
awkward and difficult for many. Yet movement is the central
component of the Exodus story, movement that does not
promise comfort nor immediate satisfaction. Our walking
together acknowledged the terms of liberation and our com-

mitment to a just future that is brought into being through action and solidarity.

The Story of the Samaritan Woman

It is not enough to read the great stories of Jesus and the Samaritan Woman (John 4:1-45), The Opening of the Eyes of a Man Born Blind (John 9:1-41), and The Raising of Lazarus from the Dead (John 11:1-44) says Raymond E. Brown, scripture scholar.[8] The power of these texts is often lost in the style of reading most common in our churches, where one person reads them aloud with minimal attention to the complicated emotional qualities inherent in the texts and important in conveying their meanings. The evangelist John wrote them as dramatic narratives in which the biblical characters are intended to confront the listeners. How can contemporary liturgical communities find a way to present them so that their potential to engage our minds and our bodies with fresh insights is not dissipated? One solution can be found in a partnership with artists.

A composer, Dwight Andrews, with expertise in classical musical traditions, black gospel and jazz styles, was commissioned to collaborate with people at Union to create a musical presentation of Jesus and the Samaritan Woman. The preparation included numerous conversations between the composer and biblical and liturgical scholars at Union in order to insure biblical accuracy and a presentation that would engage our liturgical community. Texts were drawn from the Revised Standard Version translation. Some short new texts, deemed necessary for musical integrity and chosen at the discretion of the composer, were added. Interspersed throughout was a brief interpretive commentary. The plan was to tell the story entirely through music with roles assigned to soloists, choir

[8]Because of Professor Brown's concern about the presentation of these three texts in a liturgical setting, he initiated conversation about their dramatic possibilities with Professor Robert E. Seaver and Professor Janet Walton. This conversation and subsequent ones provided the momentum for their development.

and a chamber orchestra. The performance opened and closed with community prayer.

The goal was to hear the text as though for the first time. The music offered dramatic qualities which a simple reading of the text could not hope to match. It engaged the worshiping community on many levels—intellectual, emotional, and physical. The melodies sung by Jesus and the Samaritan Woman exposed qualities in each of them that contributed to the complexity of their conversation: surprise, suspicion and courage on the part of the woman, and respect, patience and commitment on the part of Jesus. The woman had good reasons to avoid conversation with anyone in her home town and had developed ways to insure her isolation. Jesus approached her with understanding that matched her skills of resistance, and through the course of the conversation new possibilities opened up for her which, while not grasping them fully, she was willing to consider.

This service confirmed several intuitions:

1. It was music that got underneath the facts of the text to expose the feelings and intricacy of this story. For example, rhythms and melodies expressed the cunning of the woman who knew well the lines of demarcation between Jews and Samaritans and her place in this town. Music exposed her sharp wit and fierce resilience. It also communicated the persistence in Jesus' dialogue which teased and challenged her response. Music drew the listeners into the conversation as well, inviting us to see and feel the conflict, understand the offer, and respond in our own ways. It penetrated the text to suggest similar pain and possibility in our own lives as well: the agony of exclusion; the effects of judgment; the potential within a conversation with a stranger; the outcome of openness in a new encounter.

2. The compassion and courage to which the church is called and which characterizes the response of Jesus in this story is not understood solely by uncovering the facts of a situation, necessary and helpful as they are. Rather it is in identifying with the total experience of those involved that real conversation begins and conversion is possible.

An engagement with this story that includes physical, intel-

lectual, and emotional components can awaken an awareness of situations where conversion also is critical. The characters in John's narrative were playing out experiences with which we continue to struggle today: divisions based on unnecessary and unjust discrimination, rejection because of a questionable past, desire to make God into our own image or at least control the description of God, slowness to believe in any one else. Such connections are critical.

Setting this story to music was an attempt to get behind the scenes in order to find our own and others' stories within this one. In that encounter can be the revelation that leads to transformation.

The Raising of Lazarus from the Dead

This story posed a different kind of problem. How could the meaning of resuscitating a lifeless body be conveyed? While other aspects of this story are important, the primary emphasis is on the experience of Jesus' raising of Lazarus from the dead.

The story substantiates the enigma. Lazarus has been dead for four days. His body smelled from deterioration. Jesus persisted and called to Lazarus. Lazarus came out of the tomb, hands and feet bound. Just as words alone cannot describe the experience of death, words cannot convey the unusual qualities of returning to life. How then could the story be told? Through the body of a dancer, suggested Bob Seaver, one of the planners of the service.

Though the unique contribution of a dancer seemed very logical, the body-mind dualism that prevails in the doctrines and practices of the church presented an obstacle to those engaged in the planning. However, eventually a dancer, David Landis, was invited to choreograph four scenes in the story of Lazarus: the gathering of the disciples (vs. 1-16), Martha at the tomb (vs. 17-24, 27), Jesus' anger (vs. 28-38a) and Lazarus' awakening (vs. 38b-44).

Concepts and images for the choreography emerged from several sources: conversations between the dancer and the biblical and liturgical scholars on the faculty; some study of

various interpretations of this particular text; and the unique capacity of a dancer to envision an embodiment of the emotions expressed in the scenes.

The service of worship was organized to follow these four moments. They ultimately included not only dance but also congregational singing, a dramatic reading of the text, and some commentary in the form of short homilies within each section together with prayer. Although each part contributed to the success and integrity of the service, the importance of the dance is the focus of our evaluation.

Some things we learned from this service:

1. The contribution of the dancer enabled some extraordinary insights. He invited us to feel in our bodies the misunderstanding of the disciples and the hurt of Martha. His movements made visible the frustration and pain, the buildup that exploded in the anger of Jesus and finally the gradual, incredible realization of dead life revived. These feelings, with the exception (for most of us) of the last one, are common to every human being. They are felt in our bodies and known in our minds. Seeing them embodied provided access to insights about ourselves and others. In addition, the dancer pointed to the theological issue raised in the story: the connection between the death and raising of Lazarus and the death and resurrection of Jesus. After Lazarus came forth, the dancer simply glanced toward the cross in the chapel, a simple gesture that communicated the relationship between these two events and their significant difference. While both came back to life after death, Lazarus would die again. Not so with Jesus, who is a symbol of life "that death cannot touch."[9]

2. Like the story of the Samaritan Woman, to grasp the meaning of this story it is important to know both the facts and to feel the experience within the text. The dance was not a substitute for the reading of the text. Rather it was another form of encounter. It offered a tangible expression of the ambiguity and mystery that characterized what happened then

[9]Professor Raymond E. Brown used this phrase to explain this theological issue in the program notes prepared for this service.

and continues to go on now with our questions and concerns about the meaning of death and resurrection. After this experience, it is difficult to understand how liturgical communities could be satisfied by a mere reading of this story. Once it has been seen through dance, no simple reading will ever suffice.

3. Commissioning artists to work as partners in planning worship requires constant conversation so that all elements— the discipline of rigorous biblical scholarship, the needs of a particular community, and the insights of the artists—combine appropriately without one overwhelming the other. The nature of the mix is crucial.

The Time of Remembrance: The Importance of Memory

Each year during the week set aside in the Jewish calendar to commemorate and lament the Holocaust, Jewish and Christian members of the Union community have a service of remembrance, Yom Hashoah, a custom that is becoming more and more widely practiced throughout the country.[10] Planning this worship requires honesty and sensitivity. The goal of the service is neither to erase nor to assign guilt but rather *to remember;* as the title of the service implies "Remembrance is Salvation."

Questions that engage us are: How do we understand the presence of God in light of this event? What experience of worship can provide some insight into the feelings shared by Jews, lesbians and gay men, political prisoners, gypsies, Jehovah Witnesses and Mennonites, as they watched the people around them disappear? How was hope maintained in the midst of such devastating circumstances? What will the remembering do for today's religious communities? What does this event, which could not have happened without the complicity of Christians back then, mean for the church today?

[10]Resources for planning Yom Hashoah can be found in *Liturgies on the Holocaust, An Interfaith Anthology,* Marcia Sachs Littell, ed., (Lewiston, NY: The Edwin Mellen Press, 1987).

Such services must combine a spirit of soberness, repentance and commitment. Primary resources are the works of artists. Art by the children in the Terezin Concentration Camp presents stark examples of the fear, confusion, anxiety that permeated those days. Texts by Elie Wiesel, Etty Hillesum, and Yitzchak Katzenelson vividly express the horrors, anguish and disbelief felt by victims of the Nazi madness. Music which expresses images of the Holocaust, and mourning and pleas for mercy and continued belief despite the Holocaust reinforce the spectrum of feelings experienced at this service.

These artistic components are accompanied by community prayer: psalmody, selections from the Reform Jewish Prayerbook, *Gates of Prayer,* or spontaneous petitions from the worshipers as well as reflections from selected members of the community. This part satisfies our need to express publicly our sorrow, horror, awareness, commitment and to make necessary connections. However, the congregation is engaged first by symbolic language which invites us to listen and interact emotionally as well as intellectually, imaginatively as well as literally.

To run the full gamut of human response seems more consonant with the indescribable experience of this historical event than a disengaged listening.

Some important observations that derived from this service:

1. Artistic expressions offer an immediacy that facts can only convey partially because art can express intensity of feeling as nothing else can. Art transcends time in its ability to represent anguish of the past as well as of the present. As cited earlier in this book, art invites us into the realm of the symbolic where emotion can be expressed. In Susanne Langer's words: "Music sounds like feelings feel." It is critical in a service remembering the Holocaust to understand more than the facts, though in themselves they are already overpowering. But mere knowledge of facts does not induce a change of behavior. The purpose of a Yom Hashoah liturgy is not only remembering that event but making the implications of that event clear today for the Jewish people and people of all faiths.

2. In addition to the emotional content which they evoke,

the use of the arts in the service of Yom Hashoah also emphasizes the particularity of this experience in history. There are other tragedies in our world in which groups of people have been and are being destroyed but it is a serious mistake to universalize them and make the Holocaust only one more such incident. In order to grasp the meaning of any one of them, it is crucial to understand each in its own context. "It will never mean more than it was until it first 'means' what in fact it was. When people react viscerally and absolutely to Holocaust as negative symbol, they may find it possible to react equally painfully to that which the Holocaust symbolizes, but not until then."[11] The forms of art chosen for this service have emerged specifically from the meaning of this event in history, paintings, stories, music that expressed horror and loss as well as the unleashing of evil witnessed but not stopped. Through them the congregation is urged to grasp its particular significance.

When Jews and Christians gather at this service each community brings a variety of needs. The work of artists provides space for different responses since it does not prescribe the terms of our interaction. It does provide an occasion to which each person adds the connection.

Holy Week: The Double Scandal of the Cross

When a new twist of scandal was given to the cross during Holy Week 1984 in New York City, a routine response was out of the question. Both The Cathedral of Saint John the Divine and Union Theological Seminary (without mutual knowledge) took the daring step of using crucifixes with female figures as central symbols. Edwina Sandys created a sculpture called Christa, which was exhibited at St. John's. Though the corpus was similar in posture to traditional male representations there were clearly discernible female breasts and no male sex organs.

The small clay figure, Christine on the Cross, used at Union

[11]Lawrence A. Hoffman, "Response: Holocaust as Holocaust, Holocaust as Symbol" in *Worship,* Vol. 58, No. 4, July, 1984, p. 338.

Seminary was quite different. James M. Murphy, sculptor, turned the cross upside down and carved a statue of a woman standing with both her arms nailed to the vertical section of the cross and with her legs spread on the lower cross bar, expressing the violence and hostility of both physical and emotional rape.

Both crucifixes challenged the literal historical interpretation of the cross. They expressed an evolving interpretation which sees all humanity participating in the pain of crucifixion. In "Christine on the Cross" a statement of the hostility and humiliation heaped upon women in the form of rape and submission is visibly portrayed. This crucifix was used as part of a series of services planned and led by Professor Phyllis Trible during which she invited the community to a new awareness of the meaning of forgiveness. She used texts of "neglected and violated women" depicted in the Old Testament whose witness "highlights the silence, absence, and opposition of God as well as human cruelty."[12] The sculpture identified these women and women of all ages as suffering servants who have been wounded, broken and forsaken because of our iniquities.

Both pieces evoked strong, even fanatic responses. Some rejected the symbol, claiming theological inconsistency. The statue of Christa "totally changed the symbol," complained Bishop Walter D. Dennis of the Episcopal Diocese of New York. Others were offended by what they saw as the manipulation of a religious symbol to aid the feminist cause. On the other hand, some were so moved by the identification of the woman as a suffering servant that no words could adequately express their gratitude. For these men and women Holy Week had a new power that transcended the controversy over the figures.

Some important things learned from this art:

1. Art connecting the rejection of women, widespread in the church and in the broader society, with Christ crucified invited the Christian community to feel its complicity more

[12]Words written by Professor Phyllis Trible in the notes for Holy Week Services, April 16, 17, 18, 1984.

thoroughly. To ask forgiveness and to change one's attitude is a prerequisite for knowing the power of resurrection. These two pieces of sculpture in the form of the cross challenged what might easily have become a routine participation in Holy Week. They expressed the scandal of the cross with concreteness and transcendence, inviting the Christian community to new levels of awareness and conversion.

2. The power of the themes that form the basis of the liturgical events of Holy Week can be continually tapped through imaginative reconstruction and through use of biblical, theological, and artistic resources. There is little excuse for boring, unconnected experiences.

3. The emotion inherent in the events recalled in this season requires more than written texts to communicate it.

4. Art that communicates does not evoke a neutral response. New interpretations can unleash unpredicted, irrational responses that sometimes erupt in violent reactions as well as in profound moments of transformation.

Reopening Once Closed Questions: Pulpit and Table in Tension

Several years ago Dorothee Sölle, poet, theologian and faculty member at Union Seminary, led our community worship. The beauty of a sensitive, honest human being using her discipline as a poet combined to ask new questions of the liturgical community.

Sölle's meditation, "Leaving my mother's home and my father's country," was a study in the connection between the demands of church, state and family. She described incidents in her life where the values of these institutions clashed, situations which inevitably inflicted pain, resulted in rejection and demanded difficult choices. She illustrated what it meant and continues to mean to be a German woman deeply aware of the horror of Nazi Germany, and committed to eliminating the potential for any other kind of holocaust. Her story communicated the struggle to live honestly and faithfully in the midst of personal conflict and overwhelming evidence of global dishonesty and greed.

Sölle's aesthetic sensitivities are acutely developed through her work as a poet and musician. She expresses in her poetry an emotion that reaches far beyond facts. On this occasion she touched the listeners' inner being, inviting them to reflect on their own choices and stories. Because of her respect for music she can choose for worship settings, hymns and other music that make these same deep connections. Sölle's contribution to this service is an example of the beauty needed in the church today. The combination of her honesty and conviction, expressed with aesthetic depth, haunts a community indefinitely and urges a response.

Sölle's willingness to share her experience in the instance I have described and her poetic ability to communicate the fullness of it left most of the congregation speechless but with a need to respond both personally and collectively.

What she had given us was clearly a Liturgy of the Word. Now the most natural ritual response would have been the breaking of the bread and the sharing of the cup. These are the symbols which the Christian community shares in its connection with brokenness. They are also the expression of sustaining grace that enables us to continue despite desperate circumstances. But Dorothee Sölle is not ordained. Both her telling of the story and her role in the community as a profoundly spiritual person had led quite naturally to her invocation of the blessing over the gifts of bread, wine and food. To have called upon someone else was unthinkable since her leadership in this sharing of communion was essential. But it was also unthinkable at Union Seminary at this time to have an unordained woman celebrate the eucharist.

What would her leadership in a eucharist have added? The Lord's Supper is the ultimate symbol of our Christian membership. Its implications require radical choices, i.e. accepting personal and professional rejection rather than remaining silent in the face of injustice, or making changes in our commitments rather than staying in situations that undermine our faithfulness to God and to ourselves. To take part in the Lord's Supper is a sign of a community's willingness to live actively in pursuit of justice. The story of Dorothee Sölle symbolized her commitment to such an involvement. To have her follow her meditation with the traditional blessing of

bread and the cup would have connected these actions without need of further explanation.

Some painful lessons of this service were:

1. A poet's respect for words reminds us of their power to create powerful images and statements when used carefully and sparingly. Too often in our liturgies texts do not stand up well under the weight of repetition because they are empty articulations of facts without any focus that can evoke a response.

2. The separation of word and sacrament is a disastrous historical evolution that deprives communities of the essential connection between hearing the word and responding to it with one of the most ordinary functions of our everyday lives: eating and drinking. The limitation deprives communities of the basic relationship between eating at the Lord's Supper and eating at every other table.

3. The requirement of institutional ordination in order to preside at the Lord's Supper does not necessarily protect the Christian tradition. Rather it sometimes deprives it of charismatic leadership that would move a community into a more profound understanding of its life together.

As mentioned earlier in this chapter, these examples are offered as illustrations of ways in which art affects the experience of worship. Some of them demand a complicated process of planning requiring lengthy conversations with artists. Such services are probably feasible only irregularly or seasonally. Others imply developing an appreciation of art and therefore an inclusion of it regularly. The only limitations in this category are ability, willingness, time, and in some cases, money. However, all of them suggest an artistic approach to worship, one that values symbolic expressions so highly that no services would proceed without careful consideration of their non-discursive content. This approach means that we must care terribly about the use of words, the quality of the visual setting, about connections between historical images and contemporary life. It means we must engage scripture far beyond the interpretation offered in the

sermon. It means that we must recognize the potential of our bodies as well as our minds to reveal truths about our relationships with God and one another. These concerns are important but often neglected aspects of planning every service.

Working with artists is a rewarding experience because inevitably one is stimulated and provoked to new thinking and feeling. However, collaboration is not always easy. It requires foresight and courage. The next chapter offers some guidelines for a mutually enriching partnership.

5

Principles for a Partnership between Artist and Church

Never has there been a time when there has not been some partnership between artists and churches. Architects, visual artists, and musicians have worked in churches from early history, sometimes with delight and enthusiasm, sometimes with minimal satisfaction. The discussion in this book invites a partnership where the terms and rewards of the relationship are mutual. It proposes a dialogue in which church and artist envision a common task and work together to accomplish it. The following principles are guidelines to enable this process:

1. Begin with a discussion in which both the artist and church-partner express the goals each is trying to achieve. Then search out what is common to both.

The work of the Christian church is to live in such a way that belief in a divine/human relationship is revealed. This task involves continual learning: reinterpreting the scripture to incorporate changing insights, reevaluating traditions and doctrines to reflect new contexts, assessing what is going on in the world to meet contemporary needs.

Artists are uniquely equipped to interpret and even sometimes to predict what is happening in our world. They offer clues about the meaning and essence of human life. With their capacity to see and hear beyond the limitations of most other human beings, they can shape visions and perceptions so that others can identify meaning, values, ideas and emotions.

Both the church and the artist share in common a search for ways to speak the truth, to live more authentically. The church needs the help of artists to understand human life and to express the depths of truth, both human and divine. Artists need the church, a community that recognizes the importance of truth as well as the vitality of art and will provide the space and resources for interaction with it. Not only do the church and artist share a mutual goal, the embodiment of truth, but they depend on each other to accomplish it.

2. Safeguard mutual respect by establishing clear boundaries of what may or may not be expected.

While artists and the church may share a similar goal, the differences in their approach are significant.

Artists work intensely in non-discursive forms that proceed from intuition rather than well-tested facts. While they use patterns of logic to express relationships, they do not necessarily follow literal, linear patterns but rather the logic of symbolic forms. In other words, they offer vehicles of conception that contain meaning rather than proof to substantiate it. The interpretation is left to the participant.

Churches, on the other hand, come together because of agreed upon truths (for example, a creed or a sacred book) presented in a systematic fashion often in discursive or literal forms, that is, proceeding primarily from critical thought rather than intuition. Though they are also dependent on symbolic language to convey these beliefs and though they acknowledge ambiguity and possibility of change, they carefully control the interpretation of their symbols. They establish a moral structure with clear parameters emerging from their understanding of certain truths.

In mutual work these differences will be obvious. For example, a church may experience a wide spectrum of response to the work of a sculptor, such as was described in the presentation of a female figure on the cross in Chapter Four. When art is incorporated carefully into a service or the space for worship, it can make a powerful theological statement. The interpretation of any piece, whether visual, musical, verbal, or kinetic, cannot be easily predicted or controlled. On the part of both the church and artist, it is important to

consider carefully what kind of art is appropriate and how and when it is presented so that the integrity and value of art is not compromised and at the same time the church's needs are met.

3. Make clear that mutual reliance upon experience is within the province of both and that one's experience is not "better" than the other's but different.

Both the church and artist recognize the value of *experience* in enriching or changing one's way of thinking and/or living.

No one can predict how or when a moment of insight will occur. The church's task is to offer a context, one which suggests particular perspectives about divine/human relationships. The artist offers symbols, sounds, forms, or movement, some that connect with a predictable perspective and others that stretch beyond it. An example offers some clarity. Several years ago on a hot July weekend as people came into a church, they heard with amazement "Joy to the World." The reaction was one of wonder, anticipation, laughter and even some welcome conversation. No words were said in explanation before the music began. The music surprised the community and stimulated a sense of anticipation. Why "Joy to the World" in July? The community eventually discovered some of the reasons for the choice, no less a source than the scripture itself. But the experience preceded any verbal explanation. The process invited the community to probe it and interpret it before hearing any other commentary. In this instance, music infused fresh energy for the hearing of scripture and indeed participation in the entire liturgical action.

Bold expressions of imagination or passion, the gift of artists, often provide the unease necessary to enter into an experience and to hear or see something as if for the first time.

4. Insist on integration so that a clear harmony and balance makes it obvious that no part of the liturgy is an "orphan" or afterthought.

In order to utilize art as fully as possible it is critical to consider from the very beginning of any planning process how art will function and what forms of art will be used.

Though ideas may change, the interaction between all the symbolic elements will be more powerful if there is thoughtful and critical integration. Thus it is essential to eliminate that attitude which would include art as an afterthought.

Hymns, preludes and postludes will be most effective when they relate to the readings and sermon or overall momentum of the liturgy; prayers will be empowering when they are connected to the realities of a particular congregation; flower arrangements will strengthen the liturgical action when they express the beauty of a season or the creative imagination of a member of the community; symbols such as the cross, bread, water, fire, will be experienced more powerfully when they are used fully, allowing them the spectrum of interpretations they can raise. For example, bringing a different cross into the liturgy, using a loaf of bread instead of cubes or hosts, baptizing with ample water instead of a minimal drop, flooding the space with color may invite the community to fresh understanding of the deep significance of these symbols.

When a *new* form of art is introduced into a service, similar meticulous attention to its integration is important. Whether it is dance or poetry or a tapestry, its effectiveness is determined not only by its quality but also by the way in which it connects with the entire liturgical experience and its placement within it. All symbolic forms require space and time for interaction. Too many powerful symbols in succession can be overwhelming, even deadening, just as too few or none at all can leave a great lacuna. Care must be exercised to assess a proper arrangement and rhythm. Often balance is difficult. What William Bolcom says about his work as a composer applies well to the preparation of worship: "If you tie a thing together too tightly, it loses its effect. If it's too visible, it falls apart."[1]

Art forms are a rich resource for accomplishing and deepening liturgical goals when used not only for utilitarian purposes but also as significant aspects of liturgical expression. A respect for their potential requires careful integration in the service of worship.

[1]John Rockwell, "Music, Every Which Way," *New York Times Magazine,* August 16, 1987, p. 54.

5. Know that discipline has its own rewards, which cannot be achieved through shortcuts.

Choosing the most appropriate music, image, movement, or words for a particular part of any liturgy demands research, time, ability, and intuition. That choice may be compared to adequate exegetical preparation for a sermon or preparing the sketches of a new building. It calls for meticulous attention to details. For example, to find an appropriate poem or translation of a scripture passage can take hours of paging through books, reading and rereading particular pieces or sections. Once the right material has been found, rehearsing its reading is necessary. Likewise, the choice of a dancer, musician or visual artist often requires numerous interviews to find the appropriate person and then many more conversations to interpret the theological and biblical traditions that inform a text that focuses a liturgy. It is unfair both to the church and to art not to be willing to spend the necessary time and energy this partnership involves. Such respect follows from the power of an art form as well as from the significance of the liturgy.

6. Exercise appropriate leadership.

The main function of leadership is to enable the best to happen, but it sometimes demands rigorous decision-making.

Decisions about the choice of art, as permanent as architecture or as temporary as a hymn used for a service, require leadership. Given the ambiguous nature of art and the role of taste in evaluating it, decisions are often difficult. Expertise, sensitivity, and humility are needed. Ordinarily in any situation, this task will not fall to one person, but rather to a group who represent the liturgical community and who have the requisite skills to evaluate art and to understand its place in worship. Liturgy as the "work of the people" involves everyone, each person contributing her/his specific talents. Team planning of weekly worship services utilizes a variety of perspectives and offers the opportunity for those with particular expertise to take responsibility for its effectiveness. However, everyone on the committee is not an architect even if she/he knows a little about building, nor is everyone a

musician, though everyone may sing. Respect and understanding of differences is built into effective planning. Sensitive and decisive leadership enables such collaborative work.

7. Create an environment of trust.

When a decision has been made to commission an artist and a process of ongoing dialogue is put in place, both church and artist enter into an exchange of trust. Clearly neither will be able to anticipate exactly what the outcome of a particular project will be. Working with materials and ideas has its own momentum and excitement. It is critical that each party respect these characteristics of the creative process. Artists need the freedom to respond to their insights without checking every detail with a committee. The church community, on the other hand, needs to be reassured that its original intention will not be violated and its investment of time and money wasted. Frequent conversations between church and artist are crucial to maintain trust and insure mutual satisfaction.

8. Maintain an attitude of openness.

When art is incorporated into worship it is important to approach its expression with openness. What art offers may be startling. It may challenge long-held convictions. It may alter a way of seeing. It may affirm unexpressed thoughts or feelings. It may be offensive, initially or permanently. Persons get the most from art when they are willing to interact with it beyond an immediate impression or an anticipated one. Such an attitude does not imply acceptance, simply a willingness to experience something before judging it. Just as we go to museums expecting to be stretched and challenged, so no less should be demanded of our liturgical experience. Thoughtful reflection in place of a quick dismissal or an angry outburst is more appropriate in assessing art in the nave, as it is for art in a gallery.

9. Be patient: growth takes time.

Art invites lingering, pondering, repeated engagements. One exposure often is not enough. What one dislikes initially may

change to profound appreciation; what one cannot fathom or accept may become a source of surprising connection with one's own complexities and mysteries. Similarly, superficiality or inappropriateness can also be identified through repeated encounters. Pertinent examples in liturgical contexts may be: music with unfamiliar intervals, rhythms or instrumentation; visual art never envisioned as possible in church, such as a crucifix with a female corpus (as described in Chapter Four), an abstract painting or sculpture; dance or congregational movement; provocative poetry with disturbing images. Liturgical planning must include time and/or occasions for repeated engagement and evaluation. When immediate judgment is delayed there is more possibility for some rewarding interaction.

10. Demand the highest level of competence; good intentions and mere skill are not enough.

People do not hire an architect to build a house unless they are sure the person has training, experience, and a good track record. Nothing less should be expected of those who lead a community in worship. Artists provide insight and enthusiasm insofar as they have the capacity to shape a vision. At times the liturgical needs of a church require a professional artist. Resources by way of money or an acceptable exchange are required. For example, when dance is used within a liturgy, it can be more successful when the dancer has a well-disciplined body and an imagination triggered primarily through choreography. In this way the participation may be more thoroughly engaging. Another less obvious example but no less significant is the occasional employment of or invitation to a professional actor to read scripture or poetry. Professional training is not for naught. It makes a difference.

Not only do professional artists make an important contribution within a service but also in the training of amateurs. Professional artists can help a community do its own work more effectively, such as musicians teaching about good hymn singing or more effective listening, an actor providing lessons in reading the scripture or poetry, a painter explaining the use of color, a poet assessing written prayers, a designer exploring

the possibilities of space.

Artists can enhance the quality of worship in many ways. However, not all artists are skilled craftspersons and not all artists work well in a church context. It is important to take the time to find those who can collaborate with the church and who have the potential to create lasting work.

11. Good art costs.

For those churches who have resources to commission artists, it is time to begin to use them and to share the fruits of these commissions with other communities. Waiting for a better moment often results in doing nothing or very little. Churches without monetary resources can barter for what they want or need. Some communities have, as members, artists whose financial contribution to the church can be made through their art. Some have amateur artists who are not dependent on art for their main income and would be willing to contribute their services in return for the opportunity to receive some feedback. With some imagination and risk resources can often be found if both church and artist identify a mutually challenging and rewarding situation. However, in all these cases, whether involving actual cash or not, the costs of time, energy, and thinking involved in art should be compensated adequately.

12. This new creation demands persistence: don't give up!

An artistic approach to worship cannot fail; the symbolic nature of liturgy demands it. However, single experiences of art and attempts to enable fresh encounters with scripture or other related texts sometimes may be ineffective. For both the church and artist their partnership requires a willingness to evaluate, learn, change, and try again. People with expertise in liturgy, psychology, sociology, and art can be of invaluable assistance in this process. The improvement of our worship depends in part on the determination of church and artist to continue despite seeming failure or dissatisfaction or even success. Persistence is a crucial component of the unpaved road of this mutual partnership.

People gather for worship to reaffirm and experience their relationship with God. From the origins of recorded religious history we know that the experience will be holy, beautiful, tragic, and painful. It will contain moments that transcend human reality and some that connect intimately with that reality. We come not to be entertained, though that may happen, but to engage in praise and thanksgiving, to gain insight, to gather strength, and to express commitment in relationship with others.

Art enables a community to feel these intangible experiences, to discover some aspects of God's way of interacting and to see connections with our everyday lives. This partnership between art and liturgy is not without pitfalls. Throughout the centuries it has not escaped excesses or manipulation. Yet it continues to be an unmatched source of history and experience and a resource for transformation, valuable not only to the church but to society as well. To continue that tradition, it is important to evaluate our understanding of faith and of art, to explore those possibilities where artists can provide fresh vitality and energy in the church, and to take the risks of inviting them as mutual partners in the renewal of the church's liturgical life.

Appendix

Prayer and Praise: Past, Present, Future
James Chapel
September 15, 1982

Past

Prelude: "Union Theological Seminary: A Historial Perspective" film

An introductory word
A call to worship led by President Henry Van Dusen and the Choir of the School of Sacred Music film

Confession and Absolution
Scripture: Hebrews 11:17-40, King James Version
Some words on "unexpectedness": excerpt from a sermon by Edmund A. Steimle, Brown Professor of Homiletics, 1961-1971 audio tape

Prayer written by Mary Ely Lyman, Jessup Professor of English Bible and Dean of Women, 1950-1955
Hymn: "O God, Our Help in Ages Past"

Present

"Gaudeamus Hodie" by Natalie Sleeth
Scripture: 2 Corinthians 4:1-12, Revised Standard Version
Hymn: "More About Jesus" Text: Eliza E. Hewitt
 Tune: John R. Sweeney (1837-1899)

A word about the present
Litany
Sharing of the Peace

Future

"Changes" (music composed by computer)

Charles Dodge

Scripture: Revelation 21:22-22:5, The New American Bible
"Our Temple Is the Lord"
 composed for this occasion by Calvin Hampton
A word about the future
Prayer
"Vision for Tomorrow, Action for Today" Tom Hunter

Grace and sharing of food
Benediction

The Revelation of God:
A Celebration of Advent
James Chapel

December 6, 1983

I. The Opening

Slides and sounds of ordinary women
Hymn: "People of Faith" Text: Sharon Webb-Hutchison
 Tune: "People Look East, the Time Is Near"

II. The Scripture

Genesis 16:8-14. The Story of Hagar
Response
 Dance of Hagar accompanied by alto saxophone
 A Reading from "A Visit of Charity" by Eudora Welty
Prayer

The Music of Divinum Mysterium

Exodus 1:15-21. The Story of Shiphrah and Puah
Response
 "Look Over There" from *La Cage aux Folles*
 A Reading of "My Cocoon tightens—Colors tease" by
Emily Dickinson
Prayer

The Music of Divinum Mysterium

I Samuel 1:9a, 19c, 20; 2:1-11. The Story of Hannah
Response
 Hymn: "All Poor Folk and Humble"
 Text: Welsh carol adapted by Penna Rose
 Music: "Poverty" by M. Lee Suitor

A Reading of an excerpt by Mary Wollstonecraft
Prayer

The Music of Divinum Mysterium

Luke 1:26 and 39-45. The Story of Mary and Elizabeth
Response
 "The Lord is Blessing Me Right Now" arr. by David Allen
 "Count Your Blessings" arr. by R. Donnie Graves
 A Reading from "The Four Quartets" by T.S. Eliot
Prayer

The Music of Divinum Mysterium

Luke 1:47-35. The Magnificat
Response
 "Behold a Star of Jacob Shining" from *Christus*

 Felix Mendelssohn
 A Reading from *The Color Purple* by Alice Walker
Prayer
Hymn: "Of God's Love Begotten"

III. The Celebration

Food, music, and dancing.

The Exodus Story

Two Services for Week of 5 Lent
Victory from Bondage: Part I

James Chapel
April 7, 1981

The Prelude: "Prelude" Isadore Freed

The Narrative of the Exodus (Chapters 2-15) with the spiritual
"I'm so glad troubles don't last always"

The Procession (including the following alternating components)
The Reading of Psalm 130 (as expressed in the poetry of
David Rosenberg)
The Prayers of the Seminary Community
The Singing of "Guide Me O Thou Great Jehovah"

Text: William Williams, 1717-1791
Tr. Peter Williams, 1727-1796 and others
Tune: CWM RHONDDA

The Sharing of the Peace

Jesus and the Samaritan Woman

"A Fountain of Water Leaping Up Unto Eternal Life"
John 4:1-45

Commissioned by Union Theological Seminary in celebration of the legacy of the School of Sacred Music at Union (1928-1973).

James Chapel
March 20, 1985

Call to Worship

Leader: In the beginning was the Word:
the Word was in God's presence, and the Word was God.

People: In the beginning was the Word:
the Word was in God's presence, and the Word was God.

Leader: And the Word was made flesh and dwelt among us.

People: And the Word was made flesh and dwelt among us.

A Musical Proclamation of John 4:1-45 for chorus, orchestra and soloists

Music and libretto: Dwight D. Andrews, composer and clergyman, New Haven, Connecticut

Interspersed comments: Raymond E. Brown, Auburn Distinguished Professor of Biblical Studies

Closing Prayer

The Raising of Lazarus From the Dead
"I am the Resurrection and the Life"
John 11:1-44
James Chapel
April 3, 1985

I.

The singing of Psalm 117
John 11:1-16
Commentary
Dance: The disciples at a gathering. An inner chorus of distress; featuring a return to danger, and misunderstanding of fate, Lazarus' and their own.

II.

John 11:17-24, 27
Dance: Martha at the tomb, completing the binding of Lazarus. Withdrawing in sorrow and hurt to find a change of heart.
John 11:25-26
Commentary

III.

Psalmody
John 11:28-38a
Commentary
Dance: Jesus alone in a crowd. Weighed down with knowledge of his own death, regret over Lazarus' death, frustration at the disciples' lack of vision, of depth, of faith.

IV.

John 11:38b-44
Dance: Lazarus awakening. Upwelling layers of memory, of life, of joy, compete for his attention with the tunnel, the light, the grasping bindings.
Commentary
Prayer
Psalmody

Remembrance Is Salvation
Yom Hashoah
James Chapel
April 30, 1984

Yom Hashoah: A Visual Expression

I never saw another butterfly. Children's Drawings and Poems from Terezin Concentration Camp, 1942-1944.

The Precious Legacy. Judaic Treasures from the Czechoslovakia State Collection, ed. by David Altshuler.

Testimony Art of the Holocaust. From the Yad Vashem collection.

The singing of Ani Maamin ("I believe in the coming of the Messiah")

Narration

Remarks of Rabbi Mendl, the Katcher Rabbi

"A Man and His Little Sisters," from *A Jew Today* by Elie Wiesel

Response: Confession

(partly adapted from *Gates of Prayer: The New Union Prayerbook,* New York, 1975):

Leader: All peoples have suffered cruelty, and our hearts go out to them. But this day we think especially of the pain suffered by the House of Israel. Exile and oppression, expulsion and ghettos, pogroms and death camps: the agony of our people numbs the mind and turns the heart to stone. When we consider this, we are tempted to say, with one of our poets: "To me the whole world is one gallows."

 We were there but we didn't speak up it was easier "not to know."

Women: We were there when they came for our Jewish neighbors.

Men: We were there when they deported the communists.

Women: We were there when they burned the wagons of the gypsies.

Men: We were there when they put away the gay people.

Women:	We were there when they killed our disabled relatives.
Leader:	We are there but we don't speak up it is easier "not to know."
Men:	We are there when they torture our Latin American neighbors.
Women:	We are there when they kill the Jews in Argentina.
Men:	We are there when they blame the communists for all evil.
Women:	We are there when they let thousands of people starve to death every day.
Men:	We are there when they increase the probability to destroy the earth totally.
Leader:	We are there and there is silence and there was silence! How many stood aside, mute and unconcerned, forgetting the divine command: "You shall not stand idle when your neighbor bleeds."
Women:	For the sin of silence,
Men:	For the sin of indifference,
Women:	For the secret complicity of the neutral,
Men:	For the closing of borders,
Women:	For the washing of hands,
Men:	For the crime of indifference,
Women:	For the sin of silence,
Men:	For the closing of borders—
Leader:	Let there be no forgetfulness before the Throne of Glory, and let memory startle us on sunny afternoons, in sudden silences when we are with friends, when we lie down, and when we rise up.

Leaving My Mother's House
and My Father's Country

James Chapel
March 22, 1984

Call to worship

Opening hymn: "Of the Father's Love Begotten"
Text: Translated from Latin,
John M. Neale St. 1, alt.
Henry W. Baker
Tune: *Divinum Mysterium*

Scripture reading

Meditation: "Leaving my Mother's House and my Father's Country"
Dorothee Sölle

Hymn: "Joyful, Joyful We Adore Thee"
Text: Henry van Dyke, alt.
Tune: Arr. from Ludwig van Beethoven
Edward Hodges

Blessing of the food

Index of Persons Cited

Topical Index

Adam and Eve 23, 26, 27
Advent 92-96
Aesthetic depth 108
 constructs 86, education 69
 experiences 14, sensitivities 68, 108,
 values 68, 84, 86
Altar 39
 altar frontal 38-39
Amos 57
Apartheid 84, 84(n)
Apostles 22
Archeology -gical 20, 22
Architectural designs 69
 style 41
Architect, -tecture 34, 39-42, 56, 60,
 74, 79-80, 111, 115, 117
Argentina 128
Art, arts 15-16, 22, 24-25, 27-32, 34,
 37-45, 69-70, 74, 76-84, 88, 104-107,
 109, 112-119
 abstract art 45, 93
 artistic expression 104, resources
 107
Artist(s) 62, 67-70, 72, 74, 76, 79, 81-85,
 87-88, 91, 99, 103-104, 109-113,
 115-119
Asia Minor 20
Assembly hall 22, 24
Auschwitz 58

Baptism 23-24, 27
Baptistery 20, 22-23, 28, 30
Benedictine 44
Bernard of Clairvaux 37
Biblical accuracy 99
 interpretation 89, resources 107
 scholars 99, 101, 103, texts 15, 17,
 tradition 115

Bishop 22, 31
Blessing 91, 108, 129
Bread 16, 108-109, 114
 breaking of 108
British army 19

Caesar 49
Carolingian 32
Catechumen 22
Cathedral of St. John the Divine 105
Catholic (See Roman Catholic)
Ceremonies, —monial 36, 40-42, 60
Choir 36, 39, 99, 120
Christ 22-23, 27(n), 34, 80, 106
Christian(s) 20-23, 25-29, 40-41, 52,
 54, 66, 103, 105, 107-109
Christian church 51, 56, 111
 community 24, 26-27, 44, 47-48, 56,
 68, 108
Christianity 25, 68
Church 16, 29, 31-38, 40-54, 56, 58-60,
 62, 64-70, 86-88, 92-93, 95-96, 98,
 100-101, 103, 106, 111-113, 115-119
 building 32, 40, contemporary
 church 25, 28, 42, 47, 55, 58, 67, 88,
 needs of 21, 117, unity of 22
Class,-ism 60, 96
Clergy 36, 41
Communion 108
Community,-ties 16, 27, 29-30, 38, 40-
 42, 45-47, 53, 56-57, 64, 68, 86, 89-
 91, 96-98, 104, 106-109, 112-114,
 116-119, 124
 community needs 105
 contemporary liturgical community
 99
 participatory community 103
 religious community 103